Dedicated with love to my two amazing daughters, both artists in their own rite, Hunter and Caitlin Cline.

And to my fabulous art students who continue to inspire and astound me with their vision and creativity.

©2014 Dana E. Cline

Printed by CreateSpace and distributed through Amazon.com

Foreword for Parents, Teachers and Caregivers

My name is Dana Cline and for the past 13 years, I have had the privilege of teaching art to students in Grand Prairie, Texas.

This book contains some of my draw-along lessons. I used these extensively with grades Kindergarten through 2nd when I taught elementary. I did not design these lessons to teach realism or to be used by the child alone. Rather, I developed these for young children to draw with me, building confidence as they worked.

As such, you should draw with your child or student for the greatest success. Follow the step-by-step instructions. Draw each step first on your paper while your child or student watches. Then have the child repeat the step on his or her own paper. Stress individuality. For example, with the first lesson of the bear, not every bear looks alike. Some bears are not even real and maybe the colors of the rainbow.

I firmly believe that early success, however simple, produces the strongest drive for perseverance in any endeavor. As my students begin to trust their own hands and ability through following me, they were more willing to take greater risks in their art without me.

Enjoy your time with your young artist and celebrate every success hugely!

<div style="text-align: right;">Dana Cline</div>

DRAW WITH ME: Portrait of a Bear

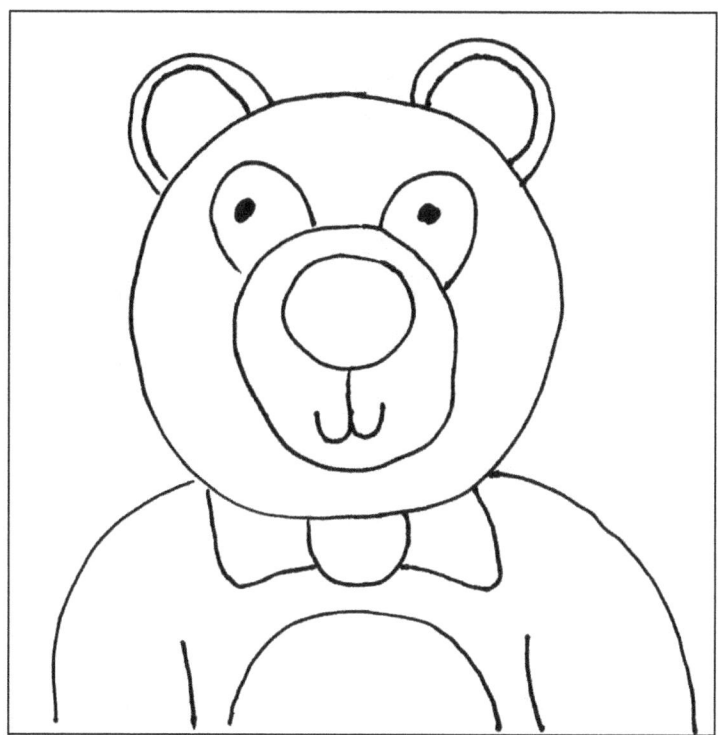

This drawing is the one I usually do with Kindergarten in the first week of school. Way back in the olden days, when I first started teaching, I used an overhead projector and transparencies. I would draw and my students would follow. Now we use document projectors but the concept is still the same for this drawing and all others that I designed.

Line by line, shape by shape and soon you will be drawing all by yourself!

Encourage your child to understand that drawing with line only is not hard; it's just sometimes complicated with several steps. As long as you don't quit in the middle, you can be successful. Also, leave your mistakes and work them back into the drawing. You'll notice one of my bear's eyes is not quite focused. At first, he looked a little cock-eyed. Then, with adjustment in the size of the eye dots, he seems to be looking up at something. If I were to finish this background, I would probably draw an object, like a string or a rope in the upper left corner. Then we also have a little mystery.

Once my students had this basic line drawing finished, I had them produce the background on their own. Ask questions such as: "Is your bear inside or outside?" "Is your bear real?". They were also free to select their own color palette, no matter how unusual. Trust your child's imagination. Kids never disappoint.

Because I guided my students to early success and because I also trusted their creative choices for completion, they begin to trust my instructions and were easier to guide when we began more difficult concepts.

DRAW WITH ME: Portrait of a Bear Step by Step

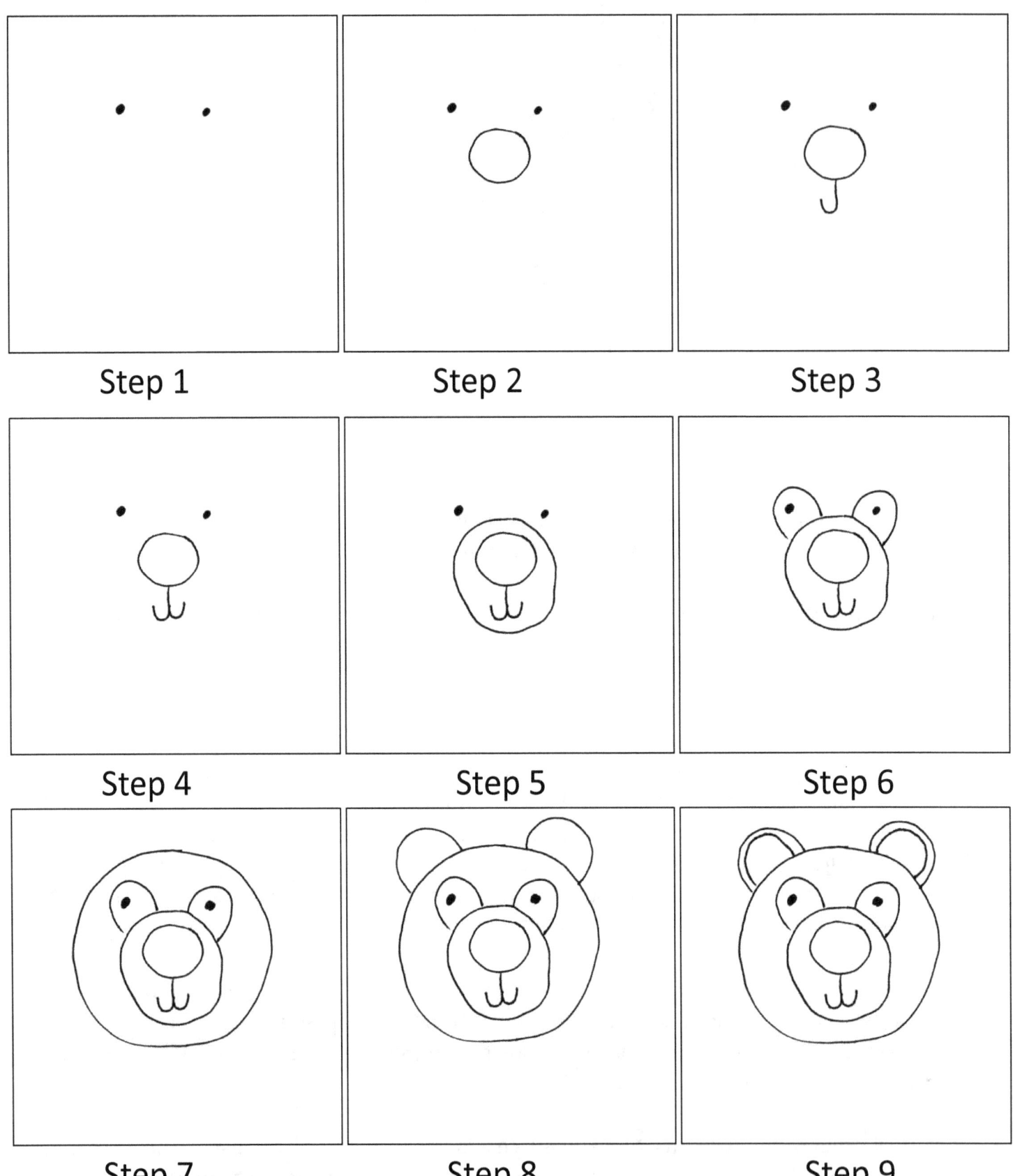

DRAW WITH ME: Portrait of a Bear continued

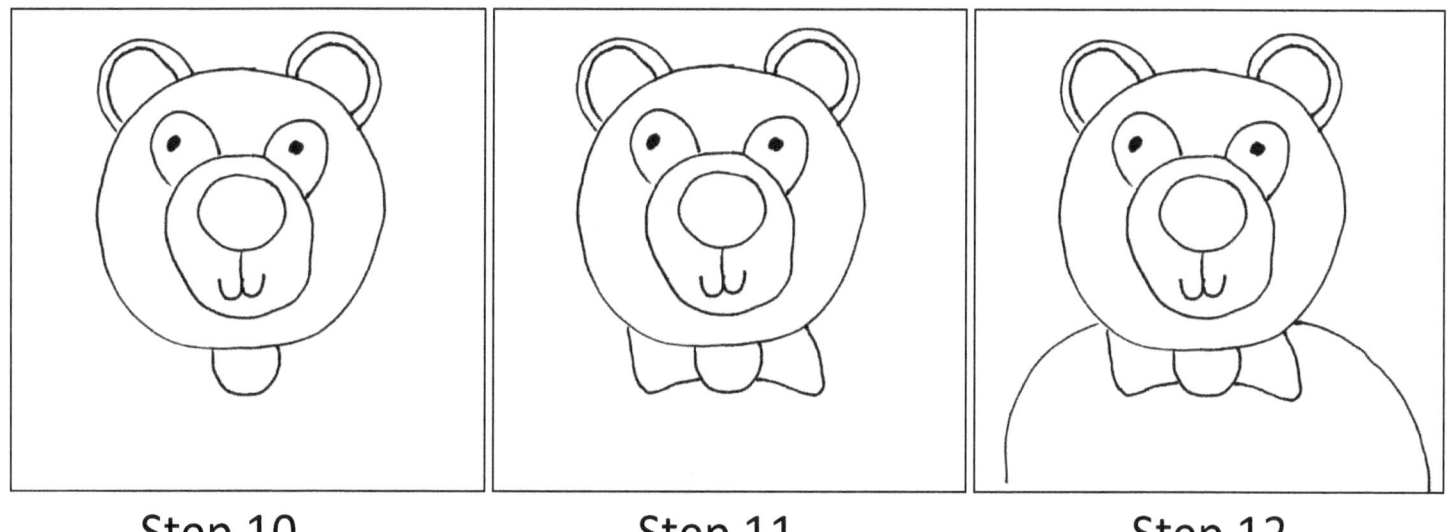

Step 10　　　　　　　Step 11　　　　　　　Step 12

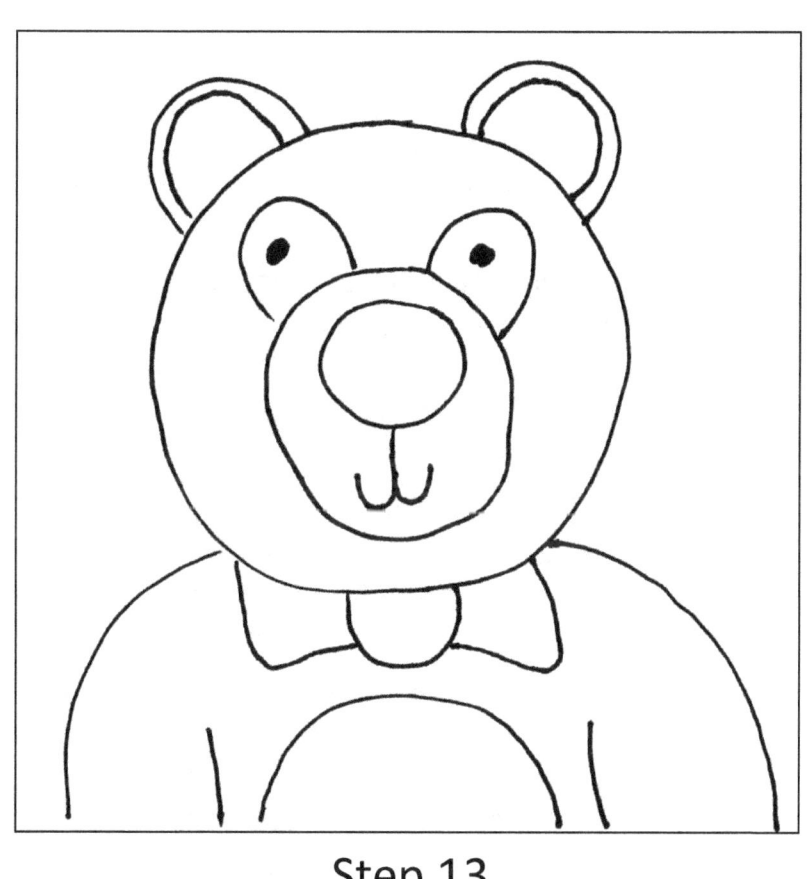

Step 13

DRAW WITH ME: Simple Fish Instructions

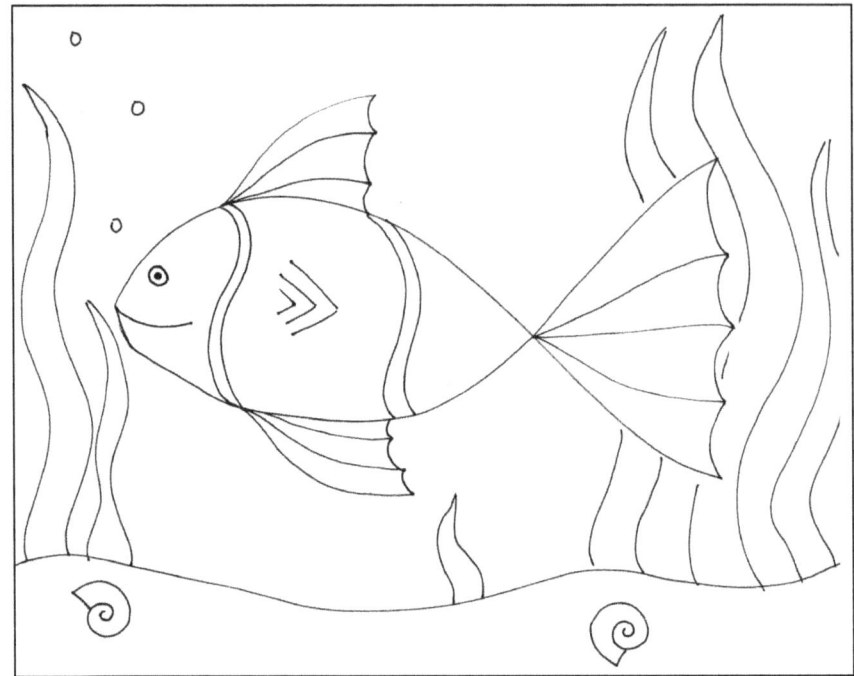

This fish is another of the Kindergarten drawings. I always finished this with a crayon resist technique, another exercise in trust.

After we finished the drawing, I would have my students color the fish and the background objects in crayon as darkly as they could. But they were given two DON'Ts.

1. DON'T color anything blue.
2. DON'T color the water in the background.

As they were coloring, I would set up a watercolor paint station with a blue paint wash and lots of paper towels and newsprint. When the first student finished, I would call everyone over and ask, "I'm going to crumple up your drawing but it's going to be ok. Do you trust me?" They always answered yes. I don't know why.

As promised, I would crumple up the fish drawing. Everyone would gasp and look at me as if I'd lost my mind. Then I would smooth it out, lay it on a piece of newsprint and paint the blue watercolor over the drawing. After blotting, the blue watercolor with the darker blue creases looks like water around the fish.

Try it with your child. They love the surprise at the end.

DRAW WITH ME: Simple Fish

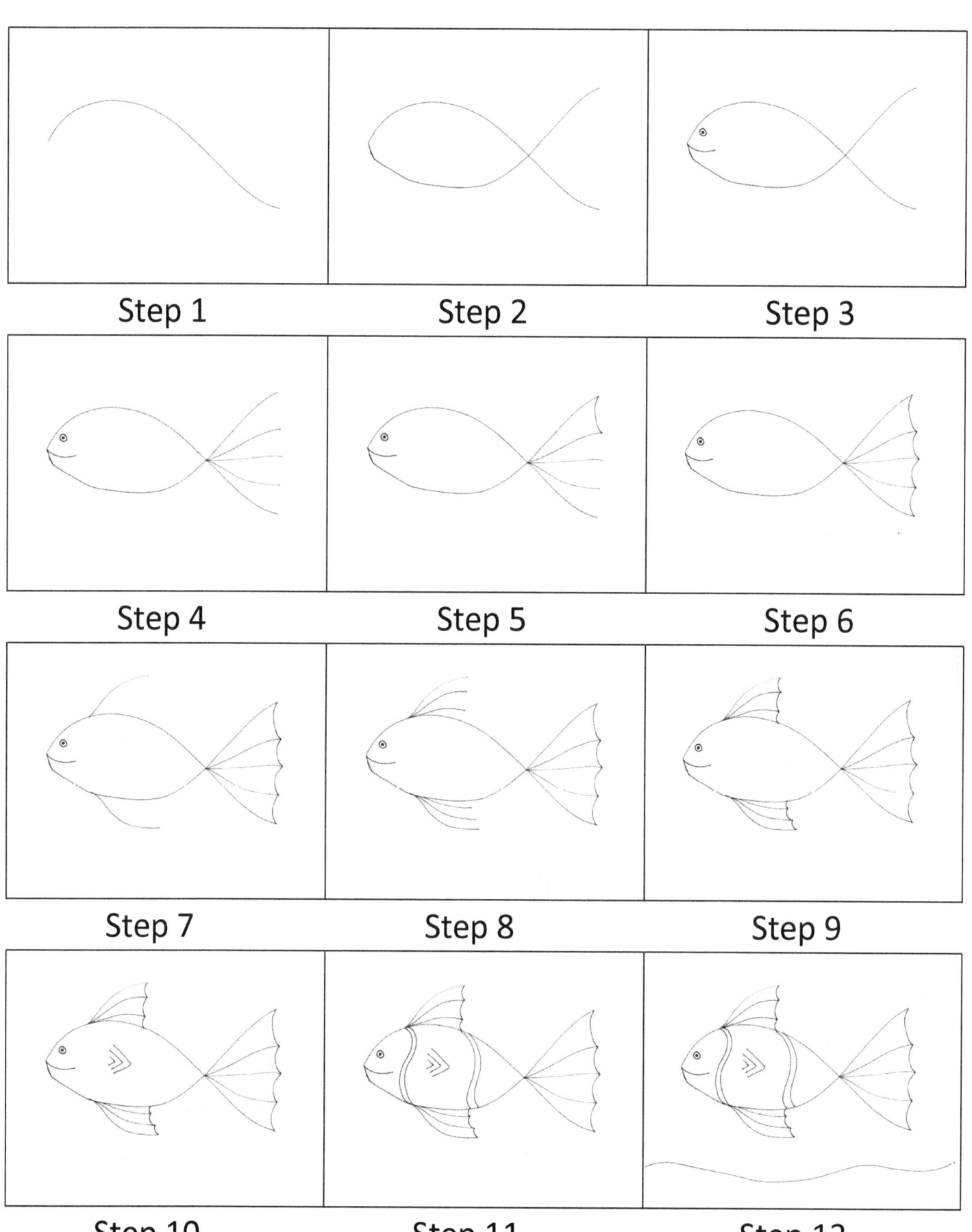

Step 1 Step 2 Step 3
Step 4 Step 5 Step 6
Step 7 Step 8 Step 9
Step 10 Step 11 Step 12

DRAW WITH ME: Simple Fish continued

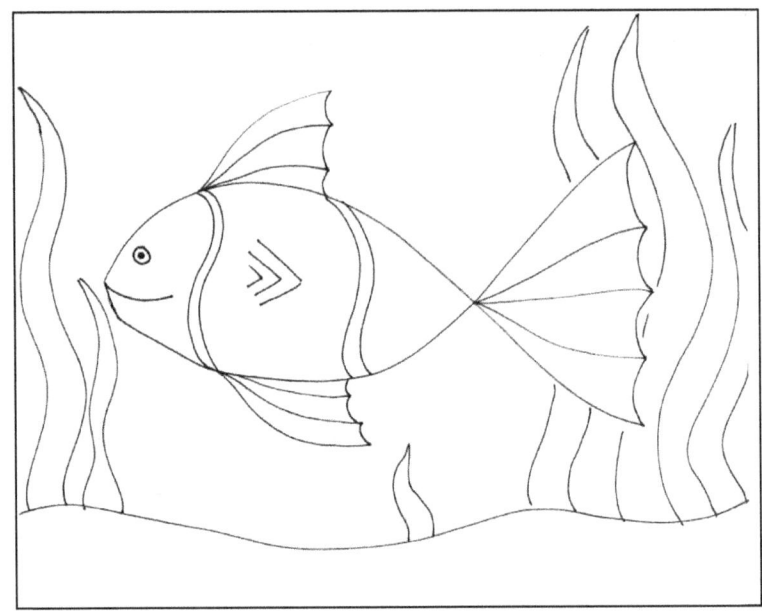

Step 13

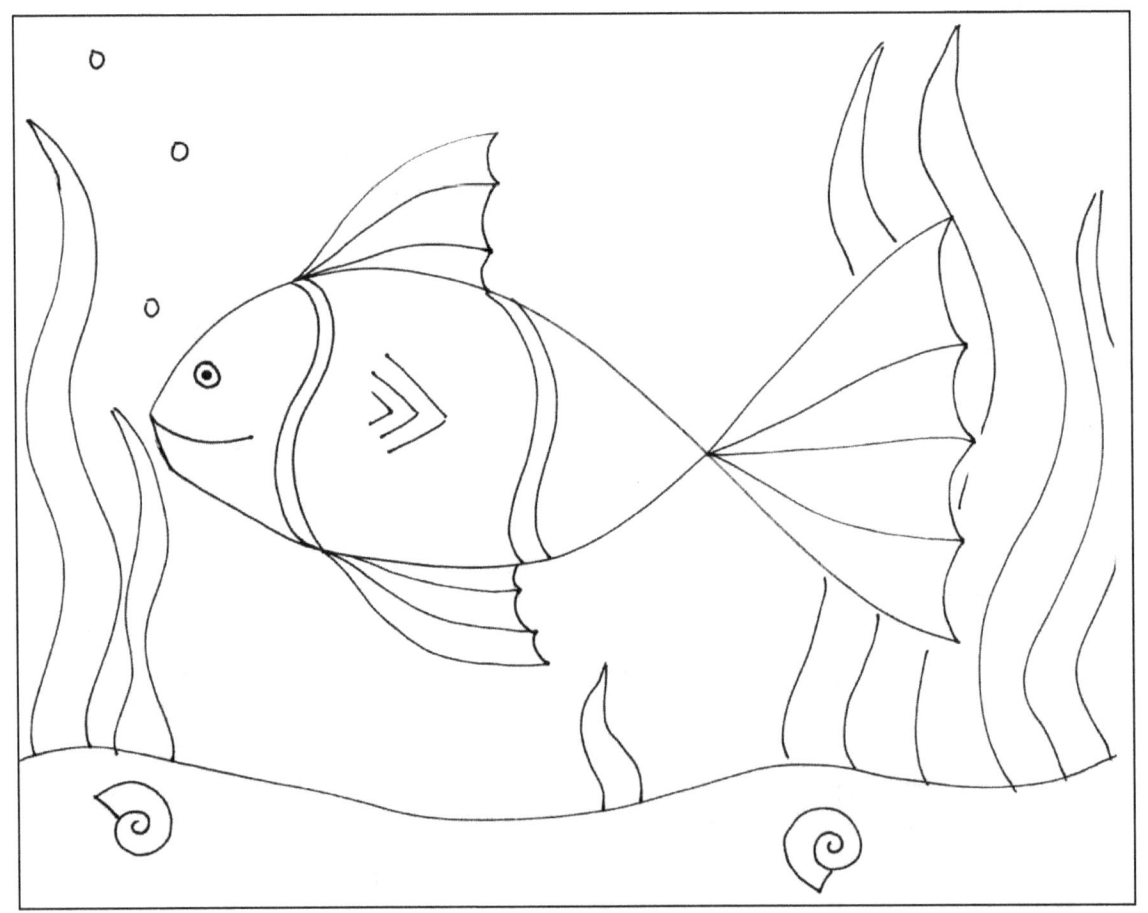

Step 14

DRAW WITH ME: Simple Landscape

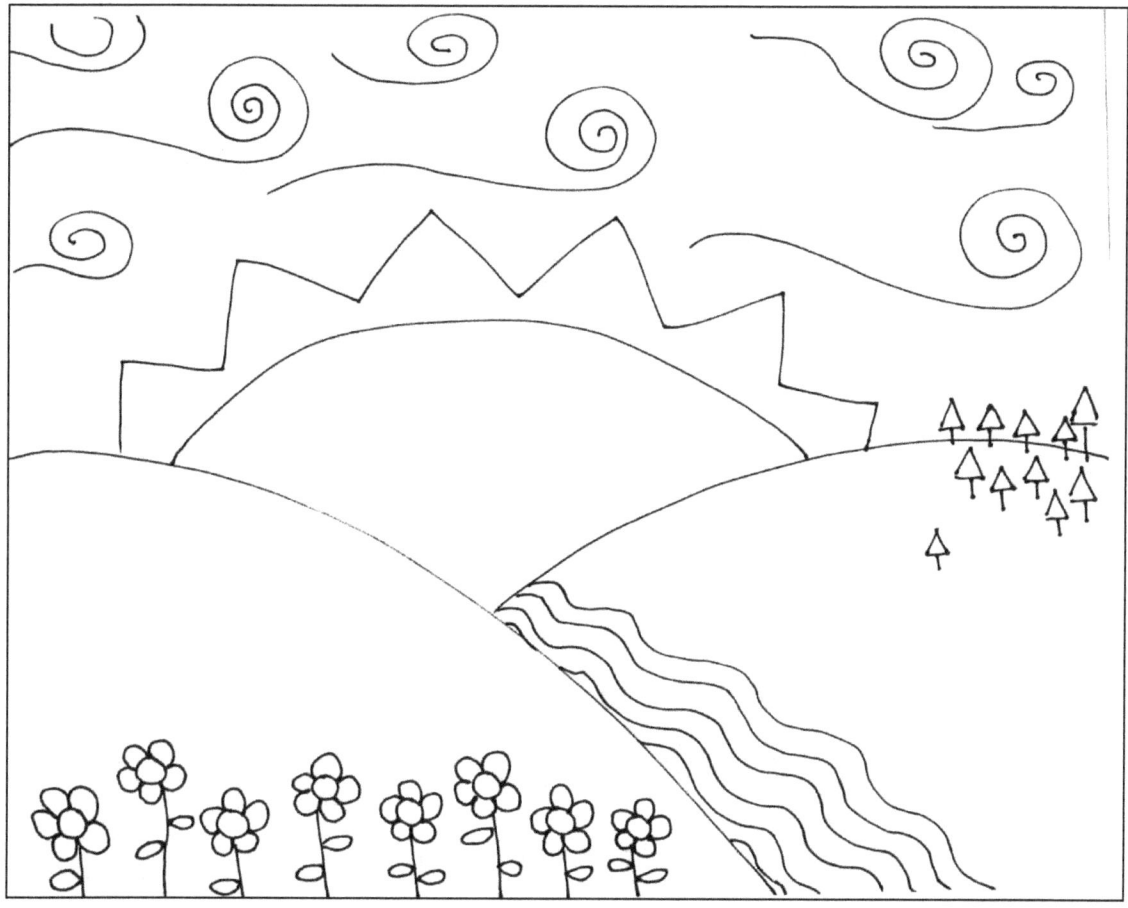

Yep, it's that sunset we've all drawn since childhood. I have used this design with students through 2nd grade for various projects. The trick with any of these line drawings is to make them more complicated as the students improve.

This one is great for teaching collage in paper or fabric for older students. Because they understand the basic lines and shapes of this picture so well, they are better able to transfer that knowledge to a different technique.

You can also add drawn patterns to each section of the drawing. Felt collage with stitched pattern is fun. If you have access to a kiln and clay, this designs lends itself well to a tile trivet.

DRAW WITH ME: Simple Landscape

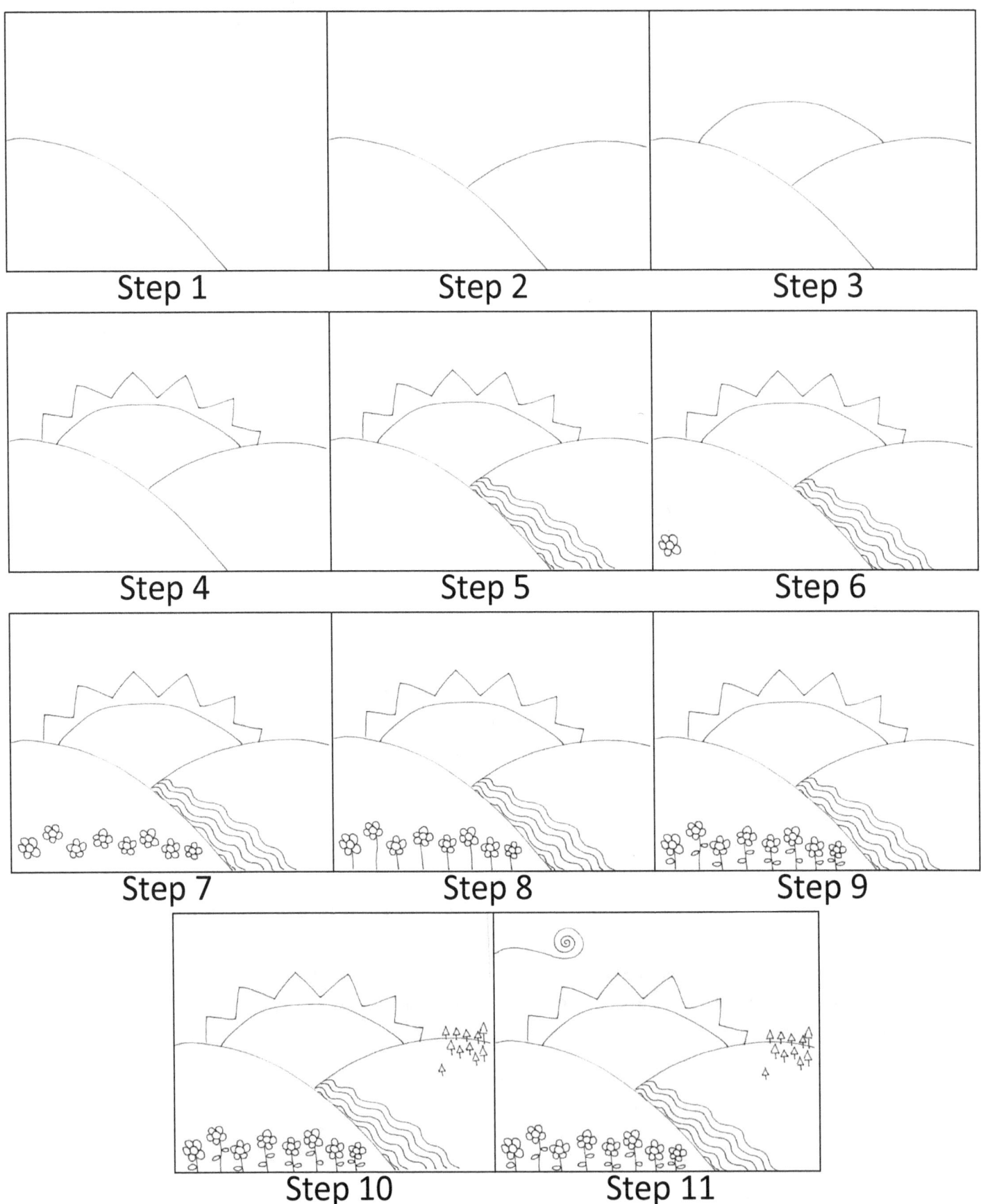

DRAW WITH ME: Simple Landscape continued

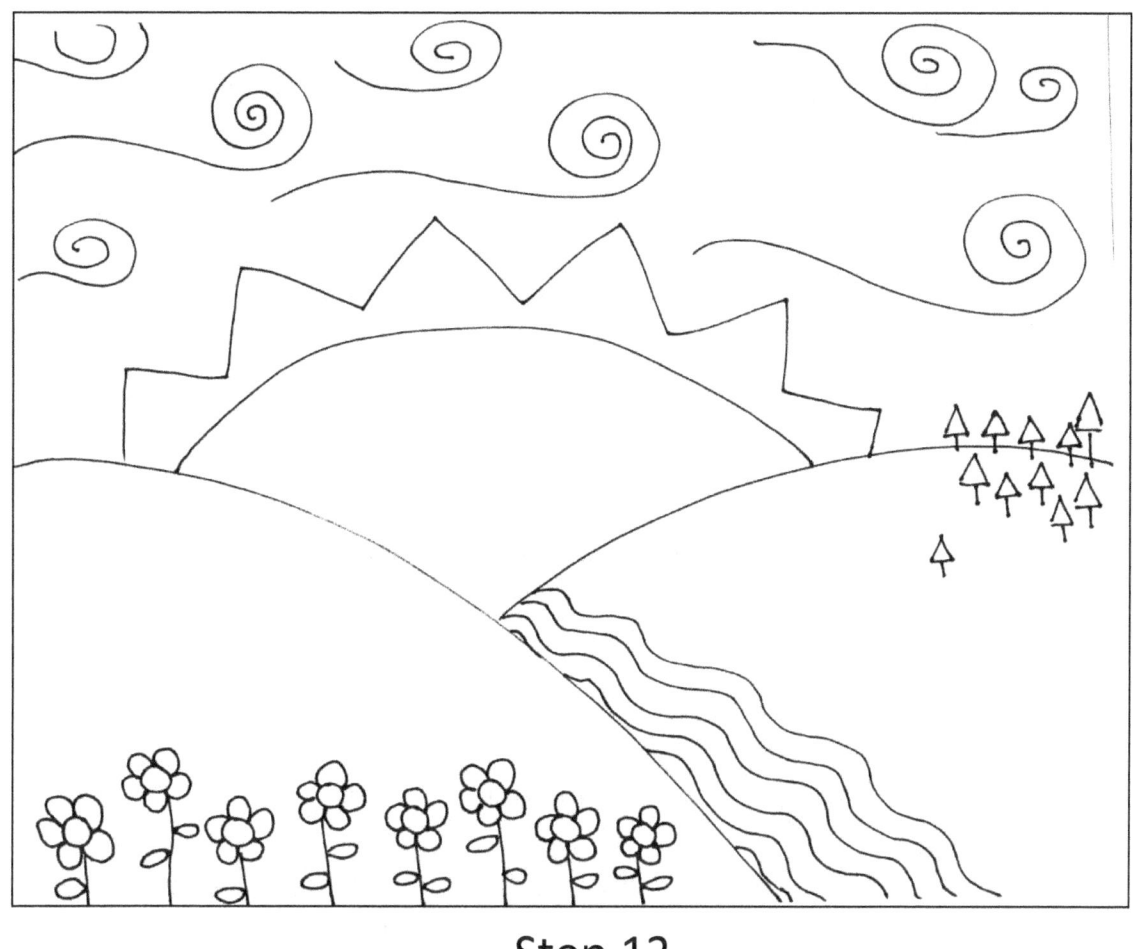

Step 12

DRAW WITH ME: Turtle Instructions

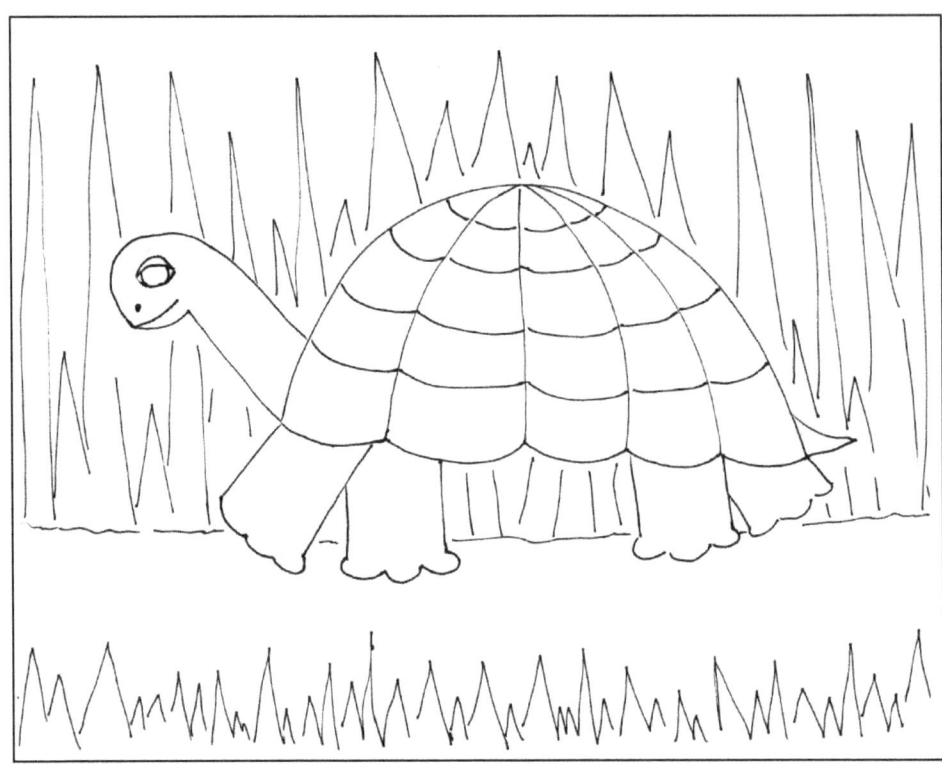

This little guy is fun and easy to work into a nature unit to support Science. Another option is to have students add details to tell a story.

For instance, I would show them just the simple background of grass but ask them to imagine what or who might be in the grass, watching our turtle walk down this path. They would add other animals or villains or elves and fairies. Then we would discuss how the different kinds of creatures and the way these were drawn made the story change. In one case, the story might be quite scary. In another, it could be funny and sweet. My practical students almost always gave the turtle a very logical environment with plenty of food.

In any case, drawings like this can be used to cross into and support the 4 core subjects of Language, Math, Science and Social Studies.

DRAW WITH ME: Turtle

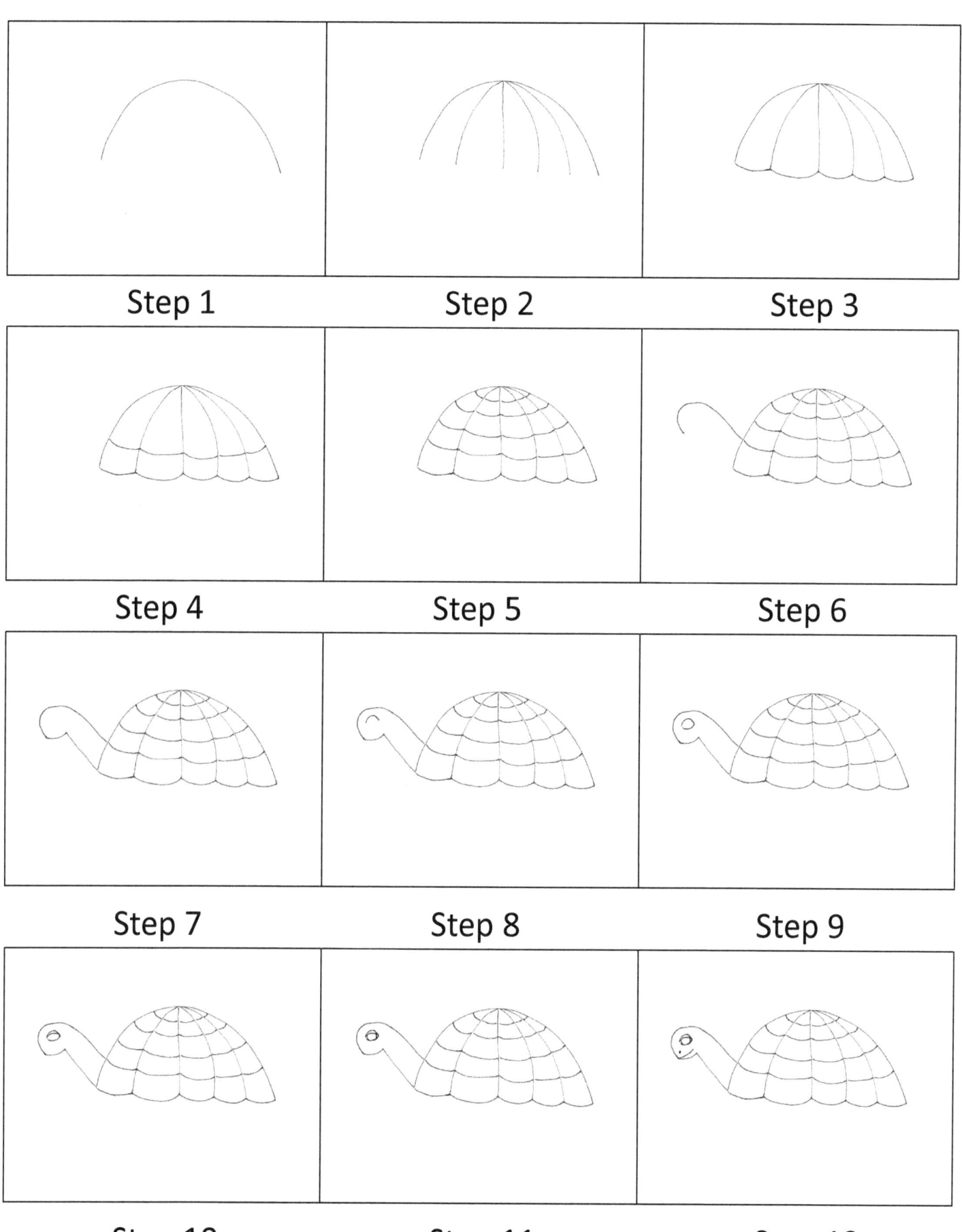

DRAW WITH ME: Turtle continued

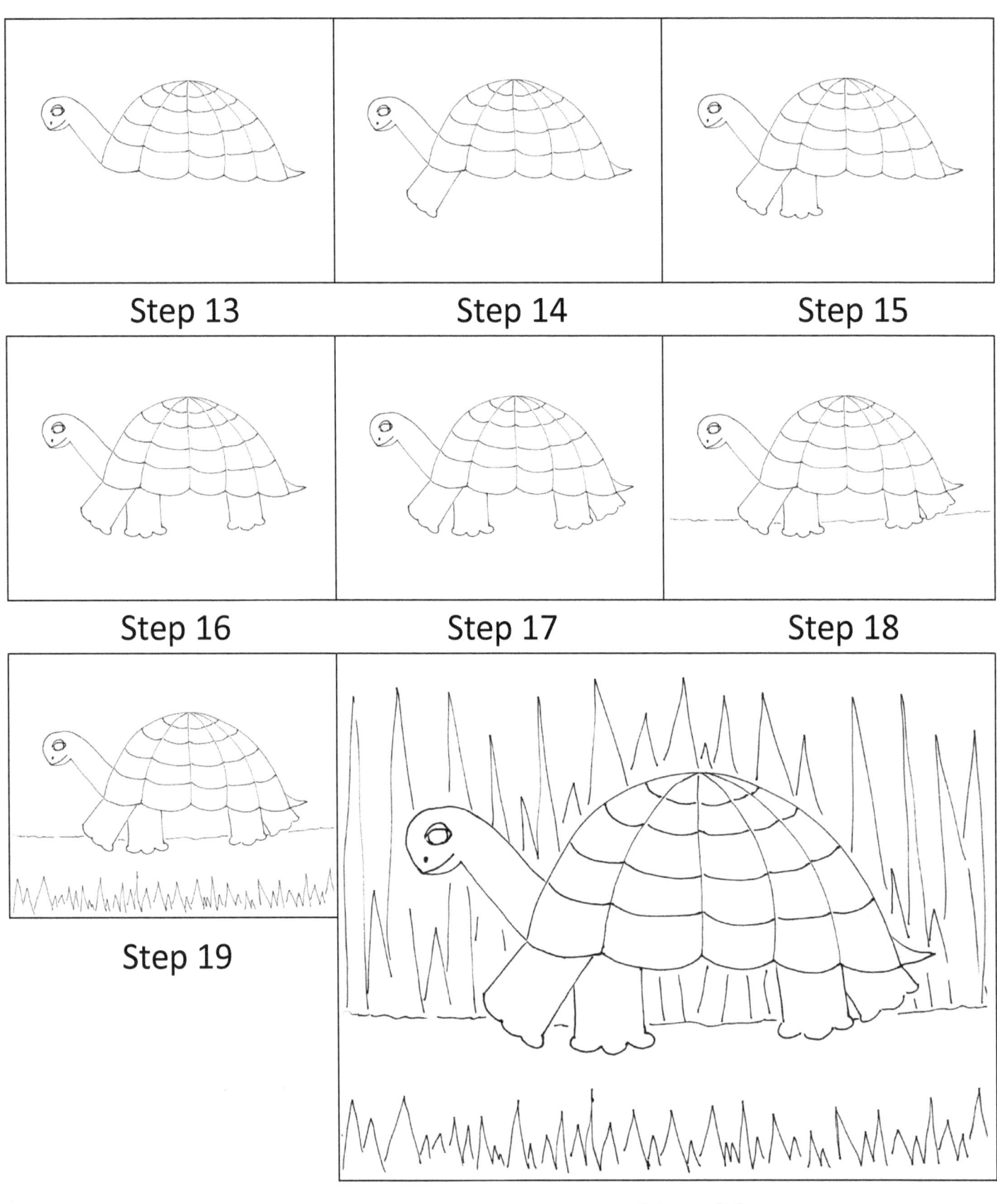

DRAW WITH ME: A Trip to the Mountains Instructions

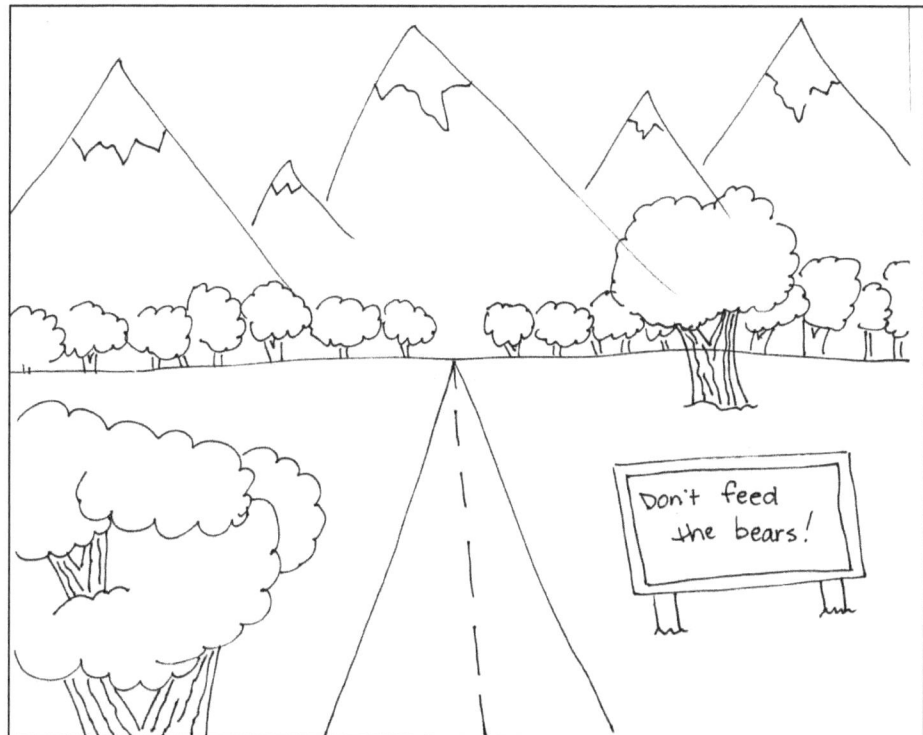

The Trip to the Mountain is the first introduction to 1-point perspective drawing. When I taught elementary school, I taught grades Kindergarten through 5th. So I had my students for 6 years. This first drawing was produced in the spring of Kindergarten and then repeated in 1st grade with an emphasis on the simple vocabulary of 1-point perspective: vanishing point and horizon line.

In the 2nd grade year, I began to require them to use the appropriate vocabulary, calling the drawing a 1-point perspective drawing, identifying the vanishing point and the horizon line, etc. We also began to discuss how our eyes work and why this type of drawing helps us draw what we see.

We continued perspective drawing through 5th grade, by which time most of my students understood the basics of 1-point and 2-point perspective.

For older students, there are a great many historical examples from Egypt to the Renaissance and even into modern video graphics to help them understand the importance of perspective drawing.

DRAW WITH ME: A Trip to the Mountains

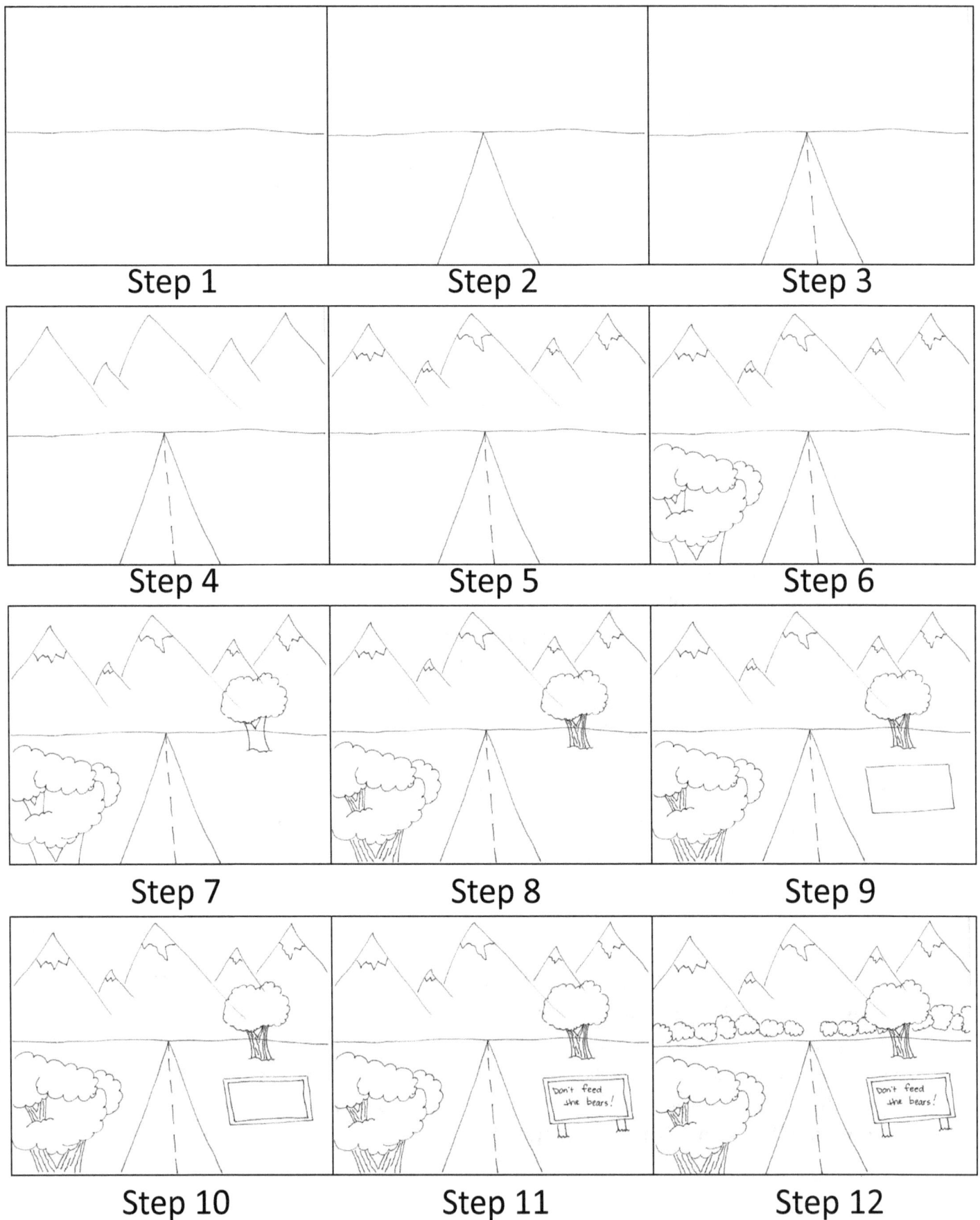

DRAW WITH ME: A Trip to the Mountains continued

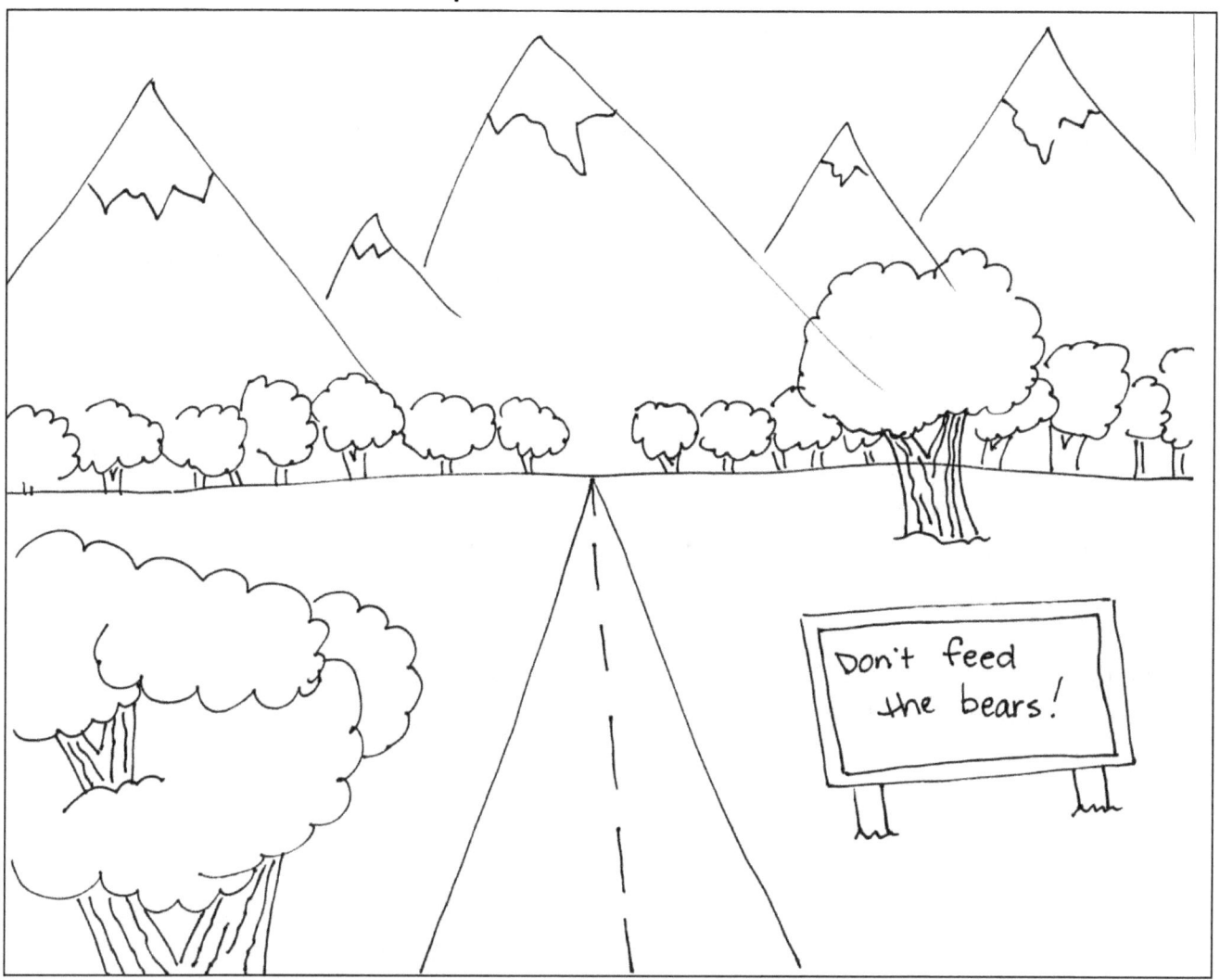

Step 13

Consider a trip to the city or a trip through the desert to a pyramid as an alternative.

DRAW WITH ME: Bowl of Fruit Instructions

This is another drawing introduced in the Kindergarten year and reviewed in the 1st grade year.

For this one, I stress individuality and allow as many opportunities for pattern and object choice as I can. There are many great historical examples that your child can follow as well. Once they have the basic concept, the possibilities are endless.

This is also the lesson where I introduce value. The idea that every object casts a shadow and also has a shadow on it is vital to help your student transition from these contour line drawings produced in conjunction with an adult to independent, realistic art.

The window also helps the child understand there is a light source while keeping them from drawing a sun in the picture, another transition step to more realistic art.

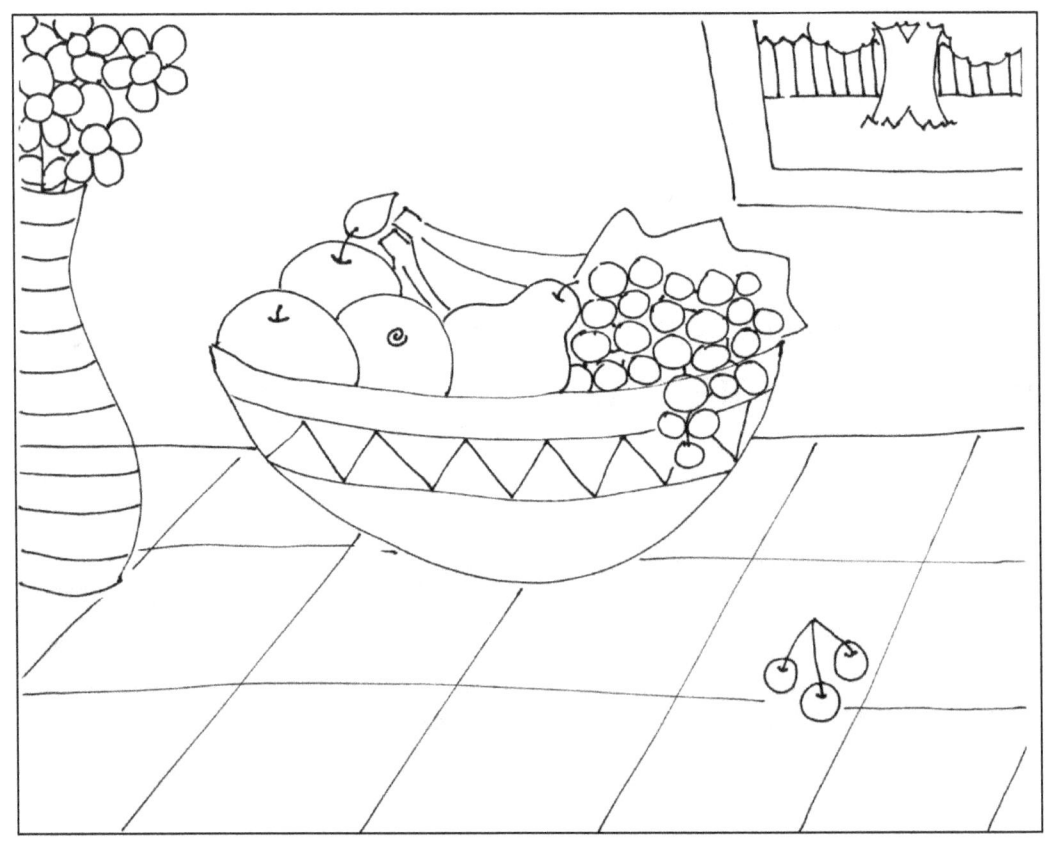

DRAW WITH ME: Bowl of Fruit

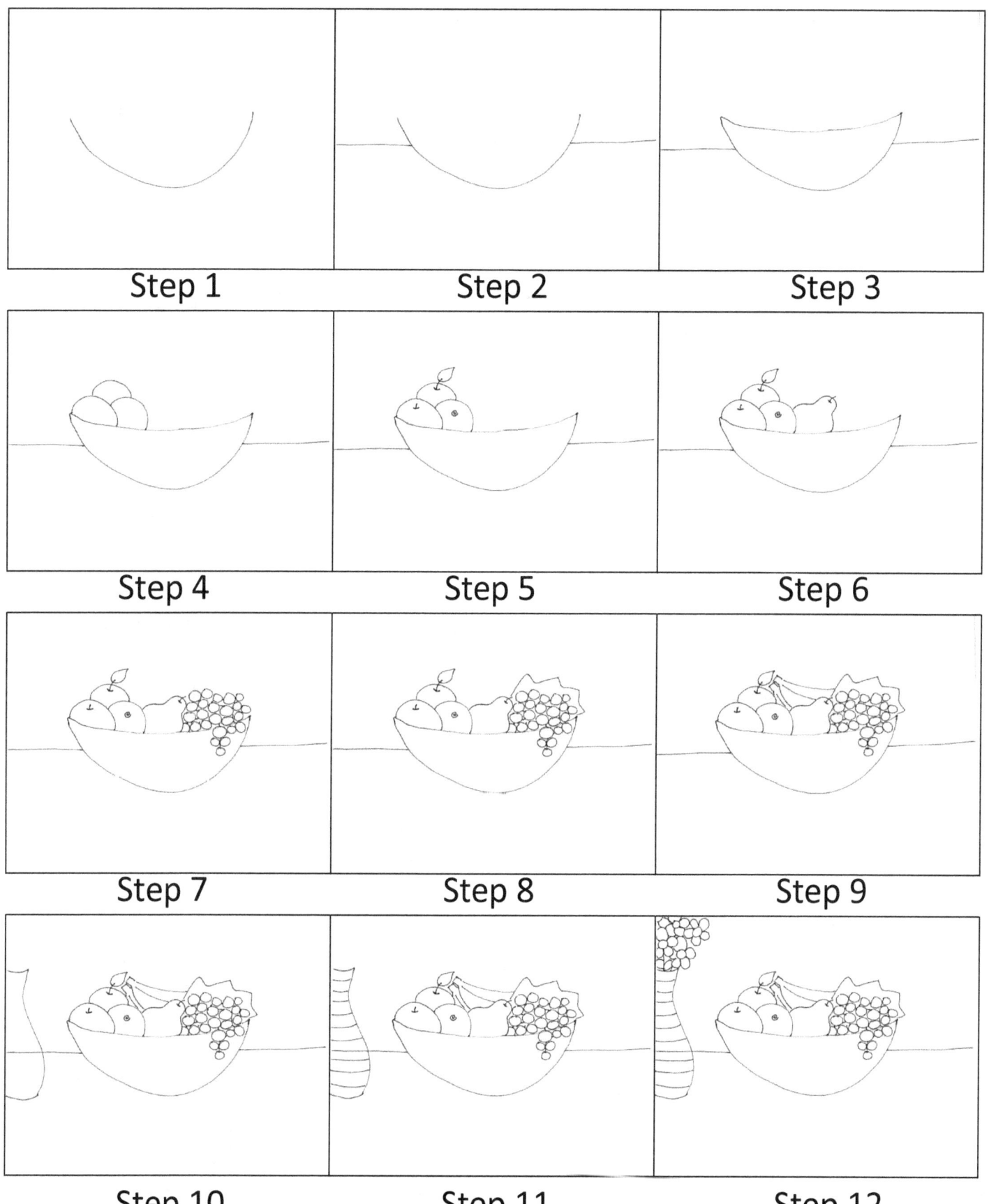

DRAW WITH ME: Bowl of Fruit continued

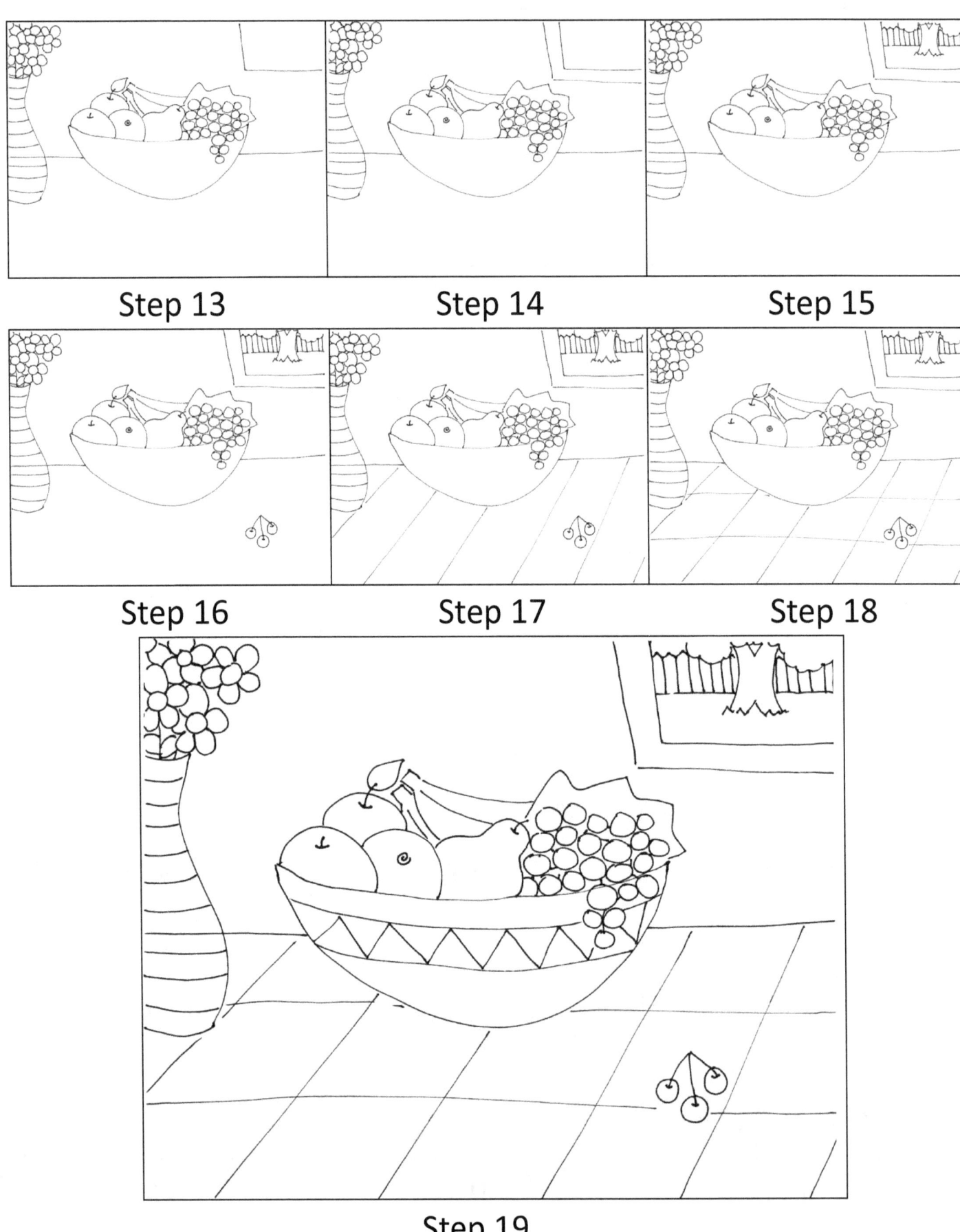

Step 13 Step 14 Step 15

Step 16 Step 17 Step 18

Step 19

DRAW WITH ME: Fancy Fish Instructions

In the 2nd grade year, I really begin to elaborate and add detail. By this point, students who had been with me since Kindergarten were all accustomed to following me and they were also very good at helping new students with the process.

For this fish, we would take value to the next level, usually mixing colored pencils for effects because of the smaller details in the drawing. I found paint was still a bit beyond most of them due to the details.

During our celebration of the final art, I would show a simple fish produced by one of the students in the previous year for comparison. Their progress was apparent and encouraging without me saying a word.

An additional tip for the increased detail: have your student color the coral as soon as each section of it is drawn. It is a bit less confusing that way.

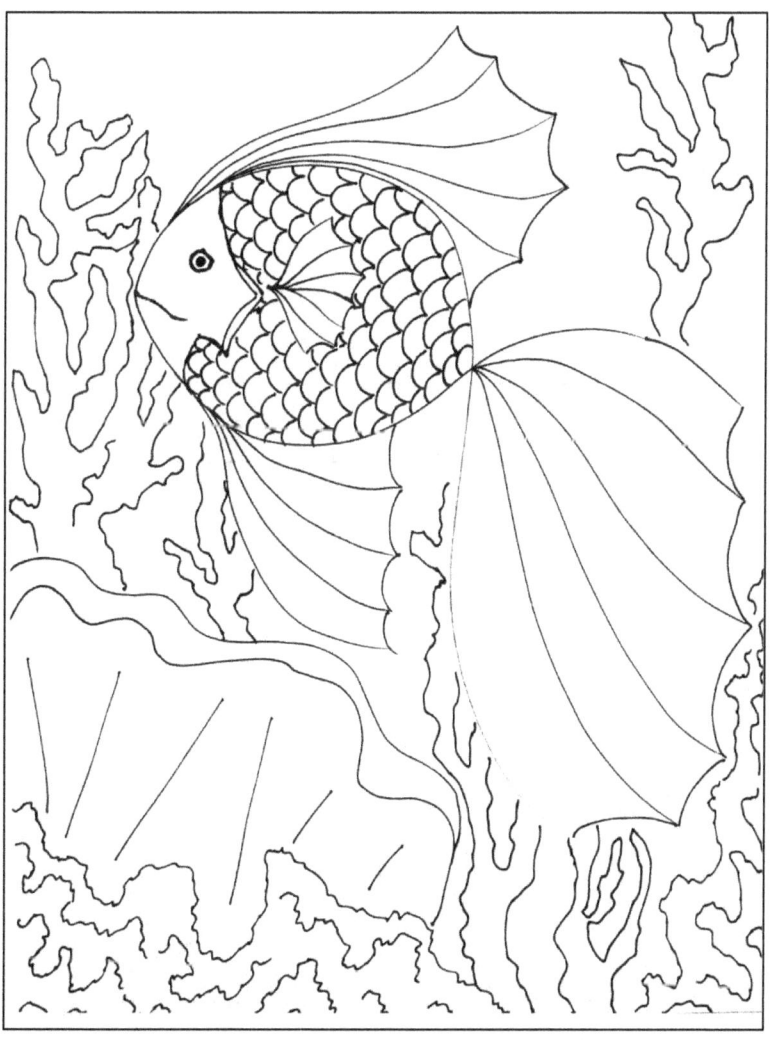

DRAW WITH ME: Fancy Fish

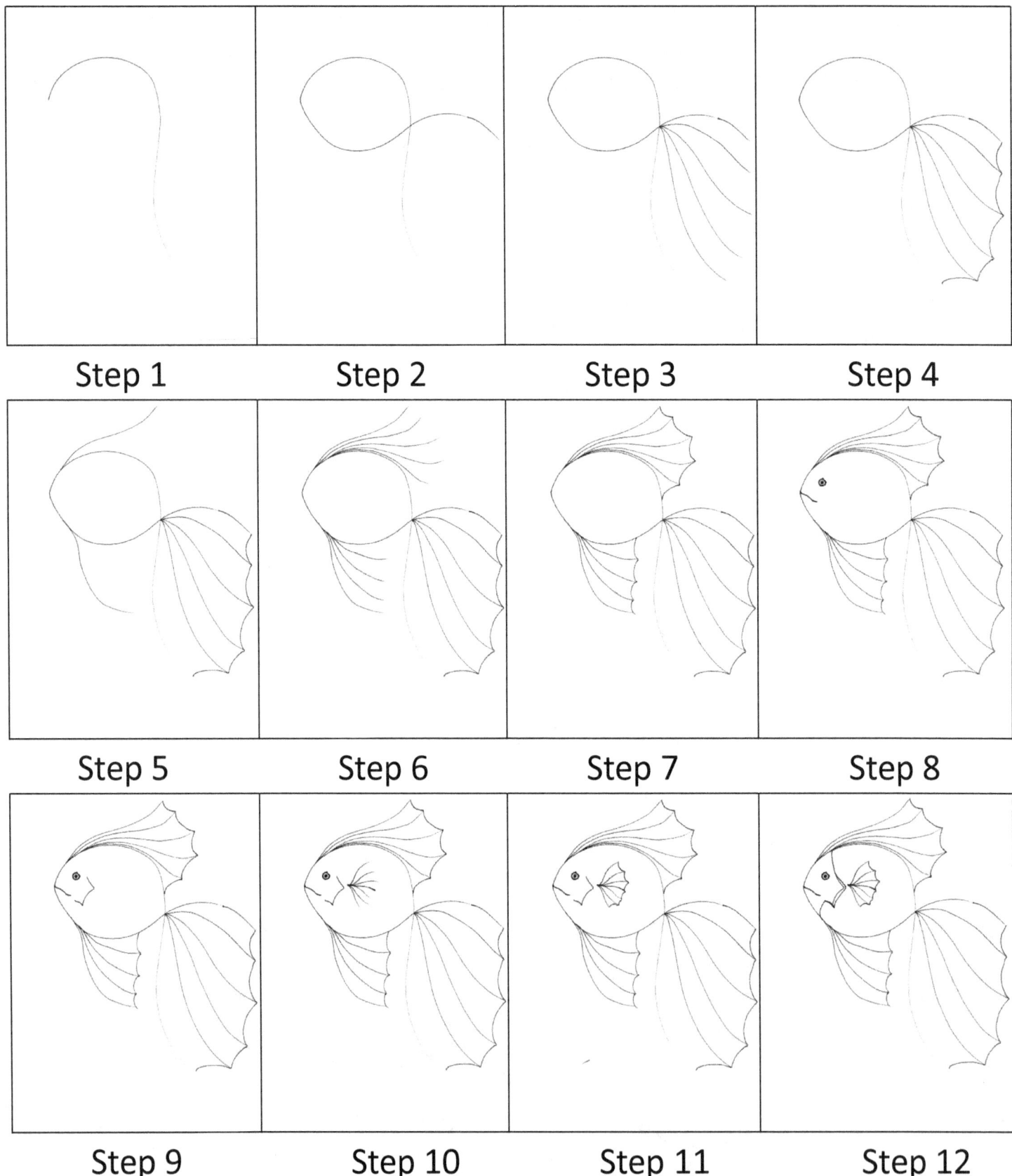

DRAW WITH ME: Fancy Fish continued

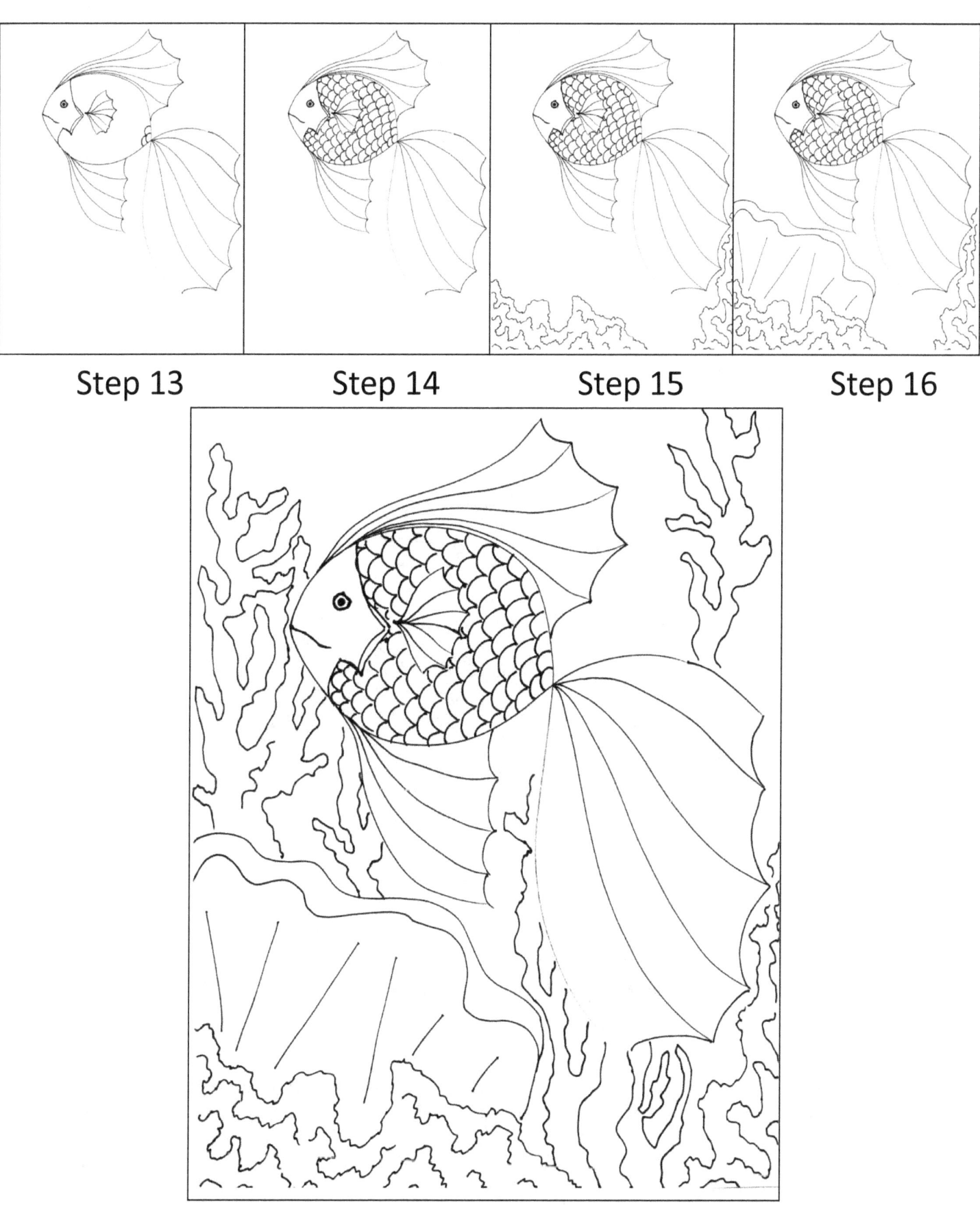

Step 13 Step 14 Step 15 Step 16

Step 17

27

DRAW WITH ME: Fancy Landscape Instructions

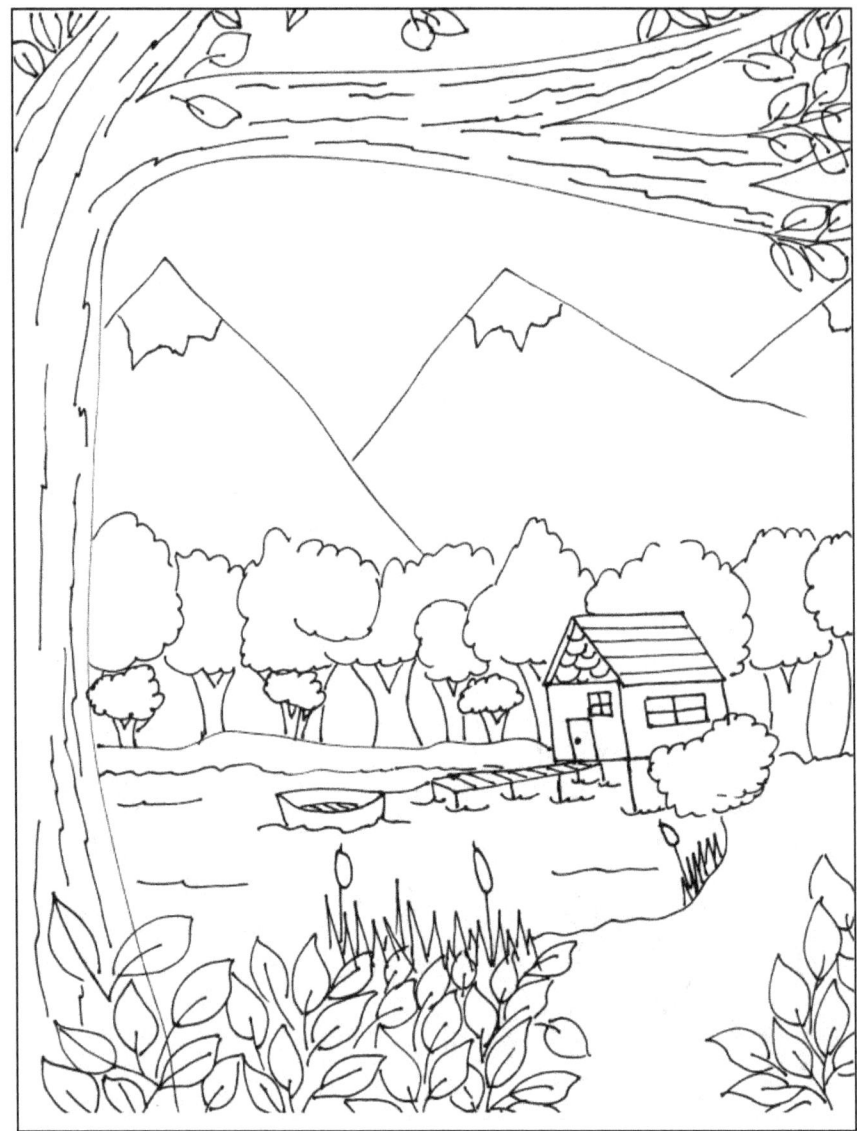

In this lesson, I talked a lot about space: foreground, middle ground and background.

This is another drawing where coloring as soon as they completed each step would help my students see objects in the artwork more clearly. We would also look at many historical examples for choices beyond the pond, boat and cabin for the middle ground elements.

Another good option for this drawing: look at the difference between lighting effects at night and during different times of the day and the changes in value and color in the landscape.

Always work in as many opportunities for personal choice as possible.

DRAW WITH ME: Fancy Landscape

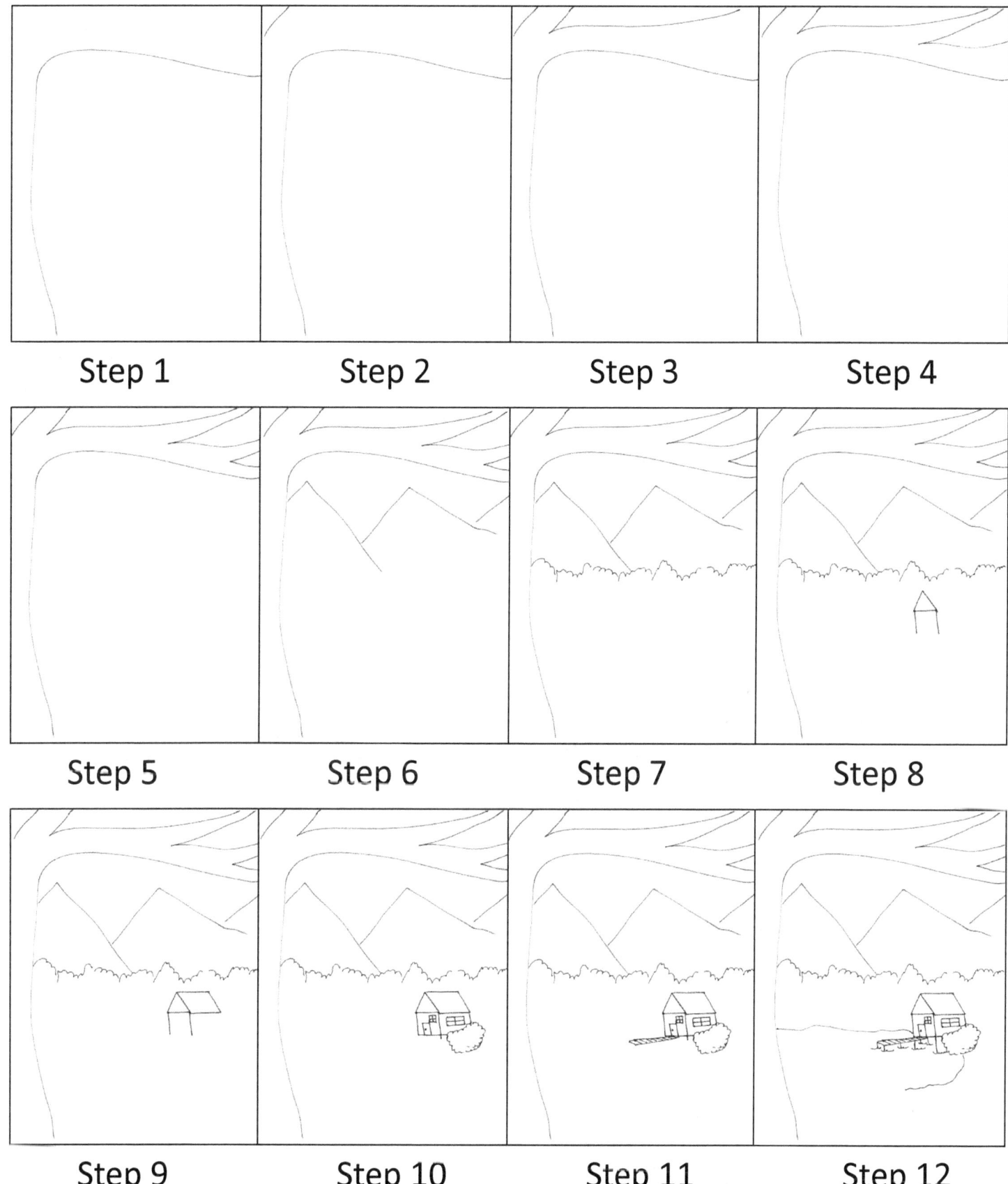

DRAW WITH ME: Fancy Landscape continued

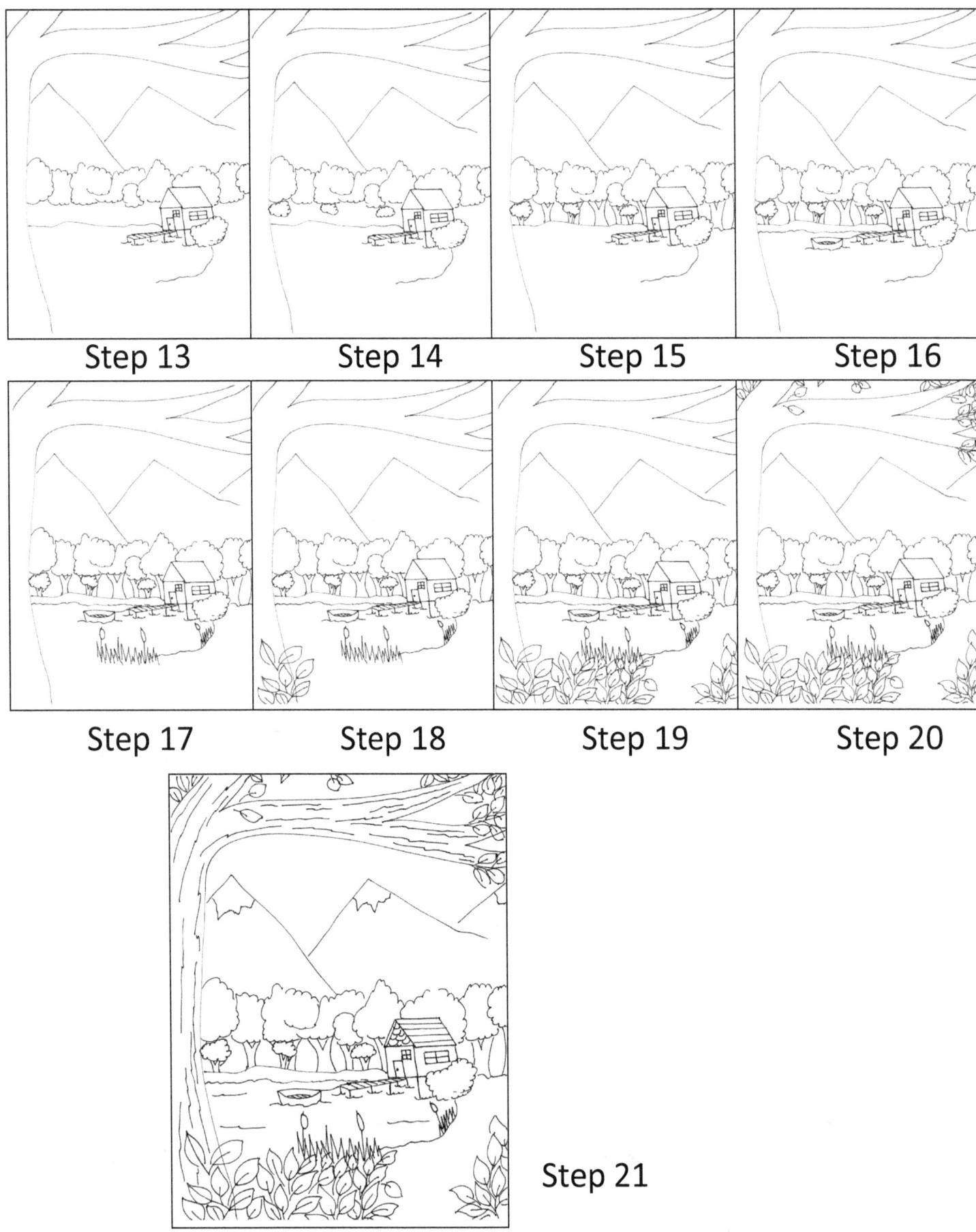

DRAW WITH ME: Portrait Practice Instructions

Self-portraits are the number one artwork kids want to produce. They love to draw themselves and their friends and family from the earliest age. However, humans are typically one of the hardest things for them to accomplish with success. I have found in my experience that children see the ability to produce a portrait as the ultimate proof of artistic talent. Therefore, they judge themselves very harshly if they don't succeed here.

I would start work on the human face in Kindergarten and we practiced it every year after that. Most years, we studied one face in a portrait at a time. But in 2nd grade, I would have them produce a group portrait with all their friends or family pictured. Be careful to give that choice with this one. I taught at a very disadvantaged school and some of the family stories were tragic. Memories would rise and it could be pretty tough. The most typical sign of trouble with any family assignment was a refusal to do it. When I introduced the alternative as a group of friends, the refusals stopped. Just be sensitive and watch for any signs of stress in your students. Notify the counselor if needed.

The lessons you will see here are as simplified as I could make them and still come up with a proportional face. As my students gained confidence and improved, we began to add more details, value and textures into the portraits over the next 5 years.

I didn't add in the figure drawing (with clothing) until 3rd grade and after we practiced that through 5th grade. When figure drawing was introduced, we started with a stick figure and talk about skeletons. Then we added clothes, skin and other details. Try it and see how it works for you.

DRAW WITH ME: Portrait Practice – The Eyes

Basic Eye
4 lines

1. frown

2. add a smile

3. inside frown

4. letter 'U'

DRAW WITH ME: Portrait Practice – The Nose

Basic Nose
5 lines

1. ⌣ small smile

2. ⌒⌣⌒ 2 small frowns

3. (⌣) 1 set of parenthesis

DRAW WITH ME: Portrait Practice – The Mouth

Basic Mouth
5 lines

1. ⌣ small smile.

2. ⌒ 2 lines on each side of small smile.

3. ⌢ 1 curve for bottom lip

4. ⌣ 1 curve for the middle.

DRAW WITH ME: Portrait Practice – The Face Map

This is the Kindergarten version of a Face Map. The art textbooks and online resources always use the better, more elaborate versions but Kindergarten and 1st grade have real trouble following those. It is better to estimate in the beginning and then graduate to more complex ideas.

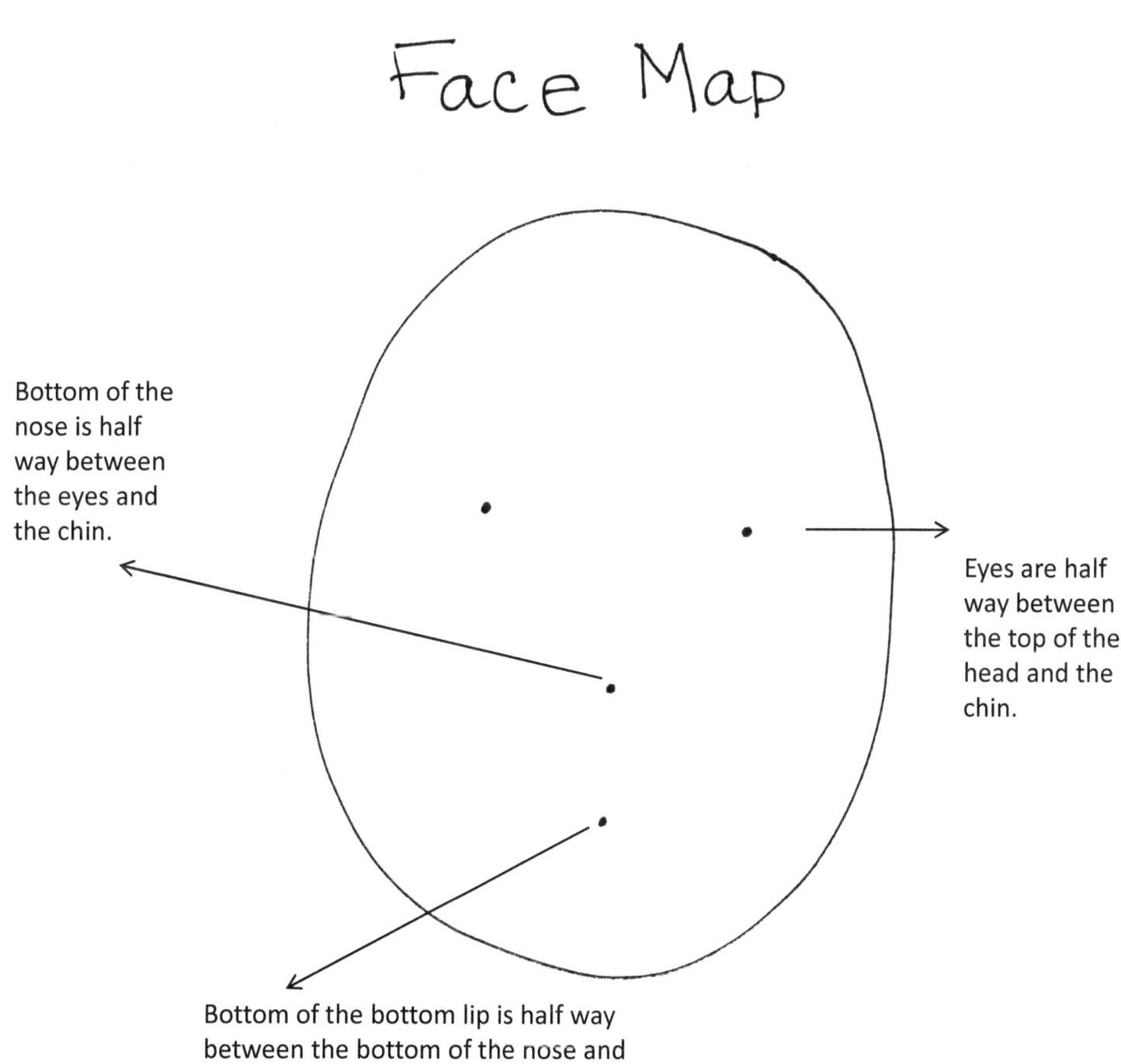

DRAW WITH ME: A Portrait

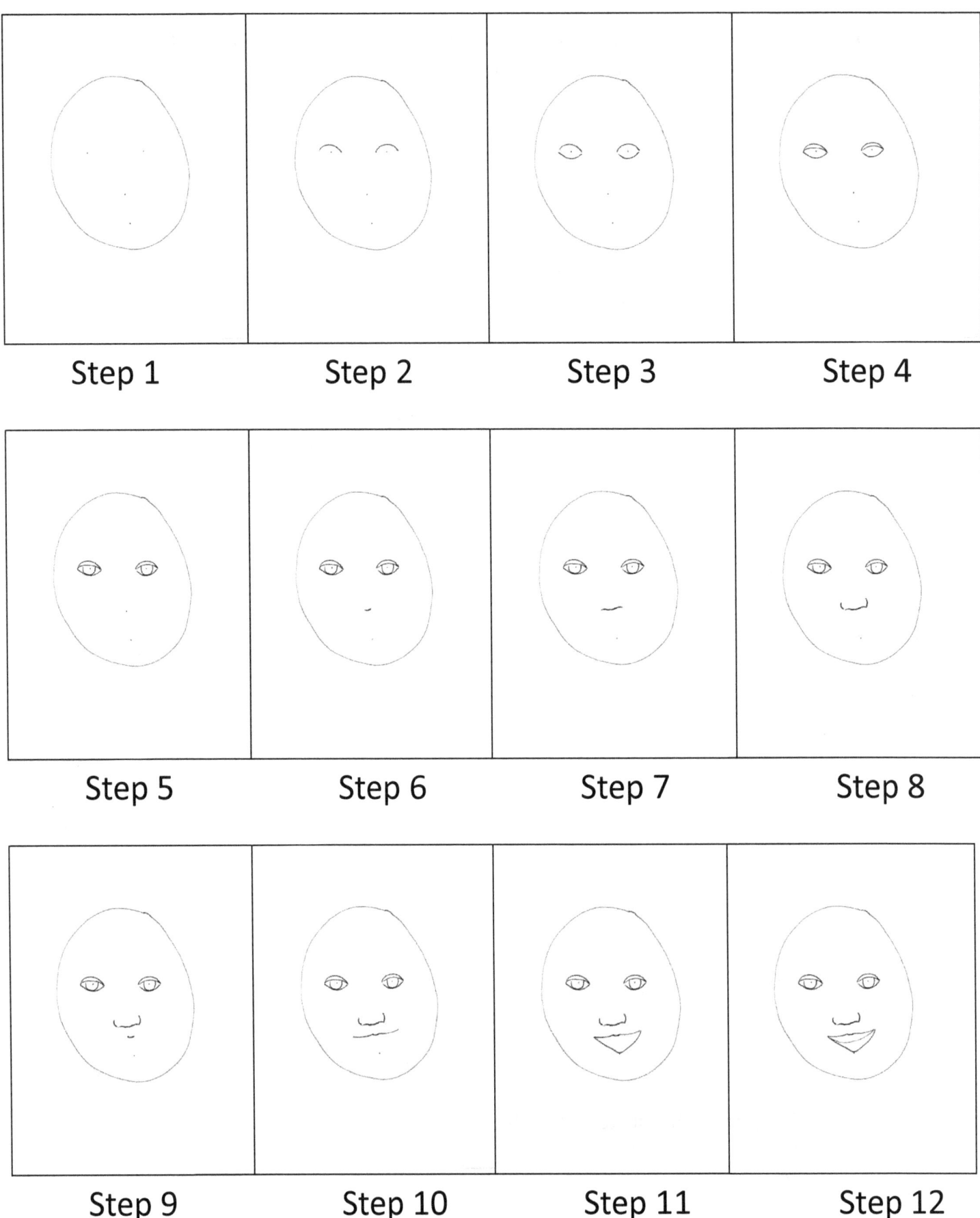

DRAW WITH ME: A Portrait continued

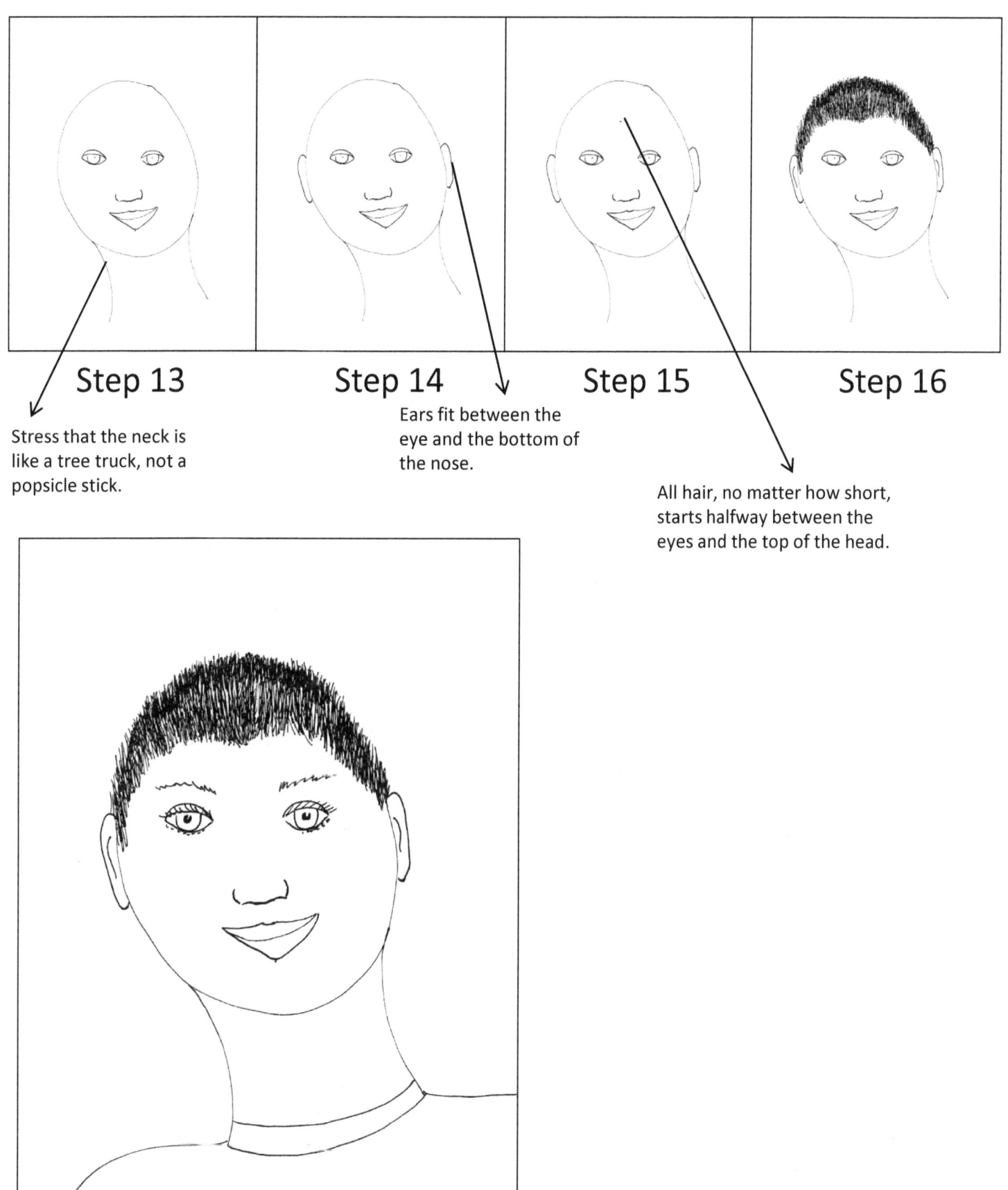

Step 13 — Stress that the neck is like a tree truck, not a popsicle stick.

Step 14 — Ears fit between the eye and the bottom of the nose.

Step 15

Step 16 — All hair, no matter how short, starts halfway between the eyes and the top of the head.

DRAW WITH ME: A Flower Garden – Seeds and Bulbs

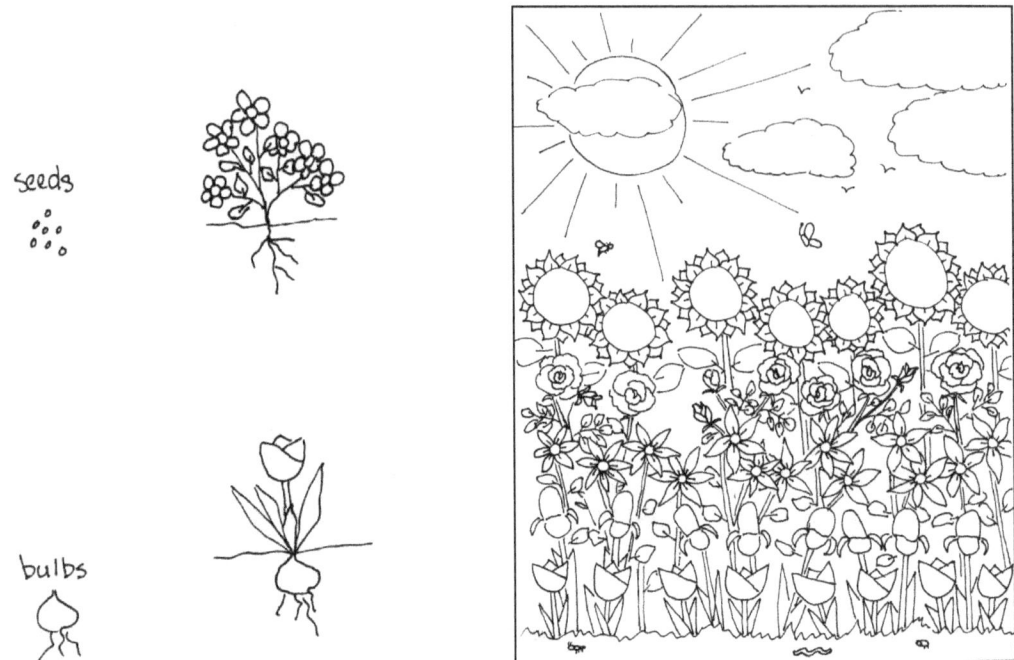

Finally, the flower garden. This is the most complicated of all the drawings I did with my students. There are many overlapping parts but it makes a great spring project with lots of science and writing ties. Moms tended to like it for Mother's Day as well, if you need a simple gift.

I always started the project with a lesson in why plants look the way they do. We would look at flower seeds and bulbs to help my students understand the differences in what we selected to draw.

We were also lucky enough to have a school garden and could venture out and see the actual plants as reference. We also talked about why we plant certain plants in the back of the garden, others in the front and related that back to space in artworks.

The most confusing part of this drawing is the overlapping. Have your child color each completed row to help eliminate this.

I typically finished this project in gel pens and watercolors for 2nd grade. The results kept them focused through the challenge of using the tools. Younger students can also produce this but modify it but selecting fewer plants and using colored pencils.

DRAW WITH ME: A Flower Garden – Practice Tulip

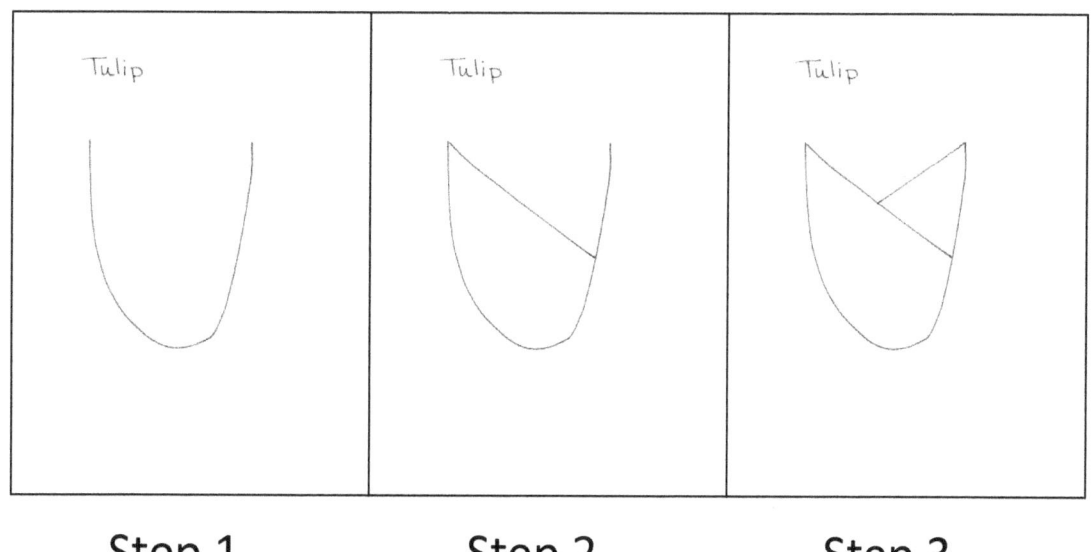

Step 1 Step 2 Step 3

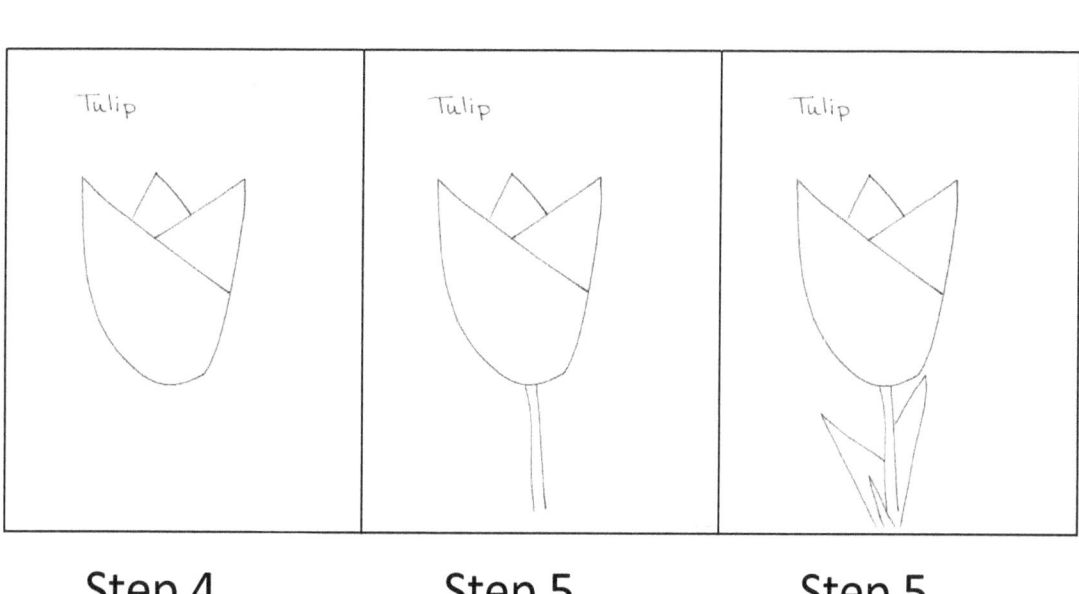

Step 4 Step 5 Step 5

DRAW WITH ME: A Flower Garden – Practice Daisy

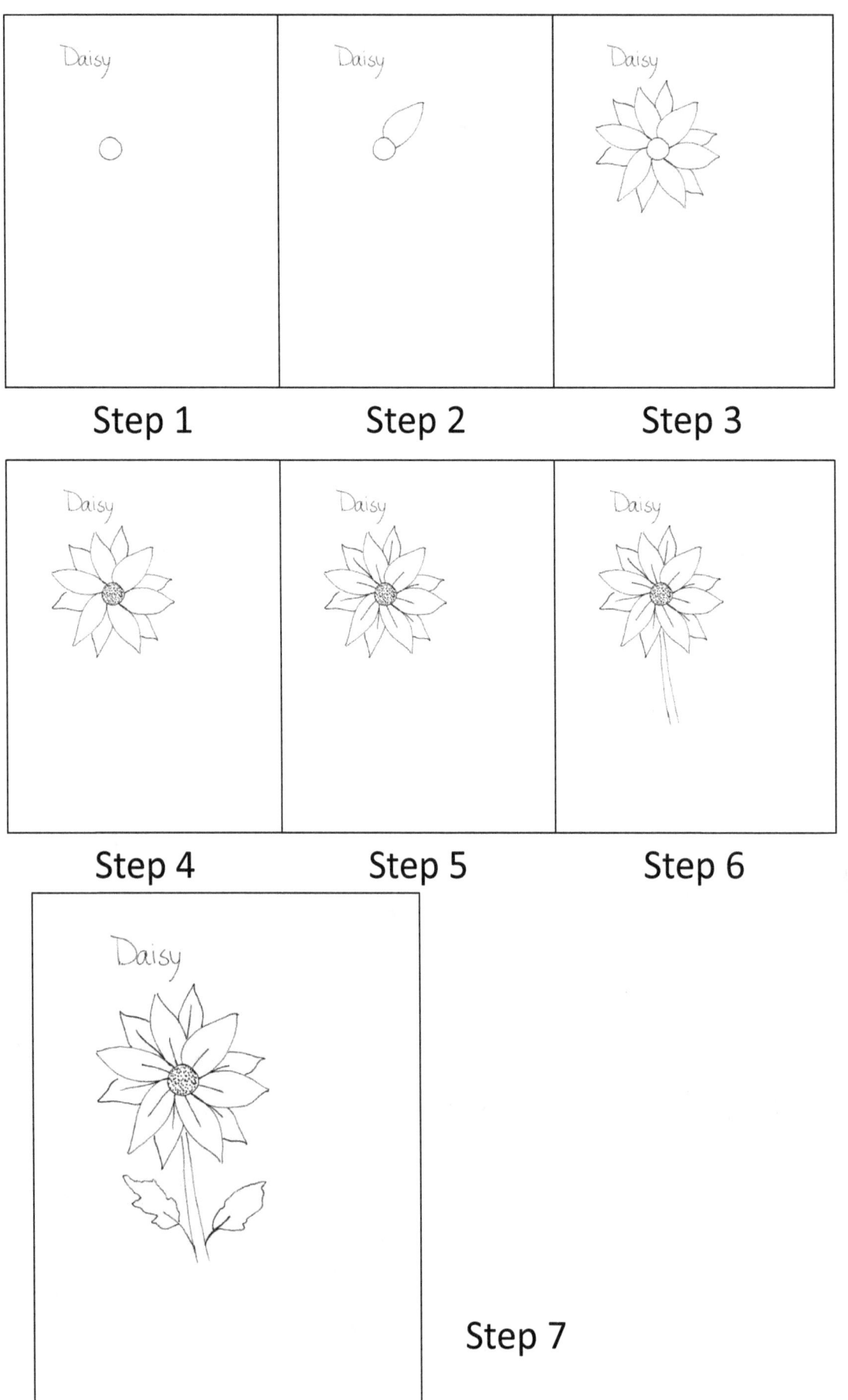

DRAW WITH ME: A Flower Garden – Practice Iris

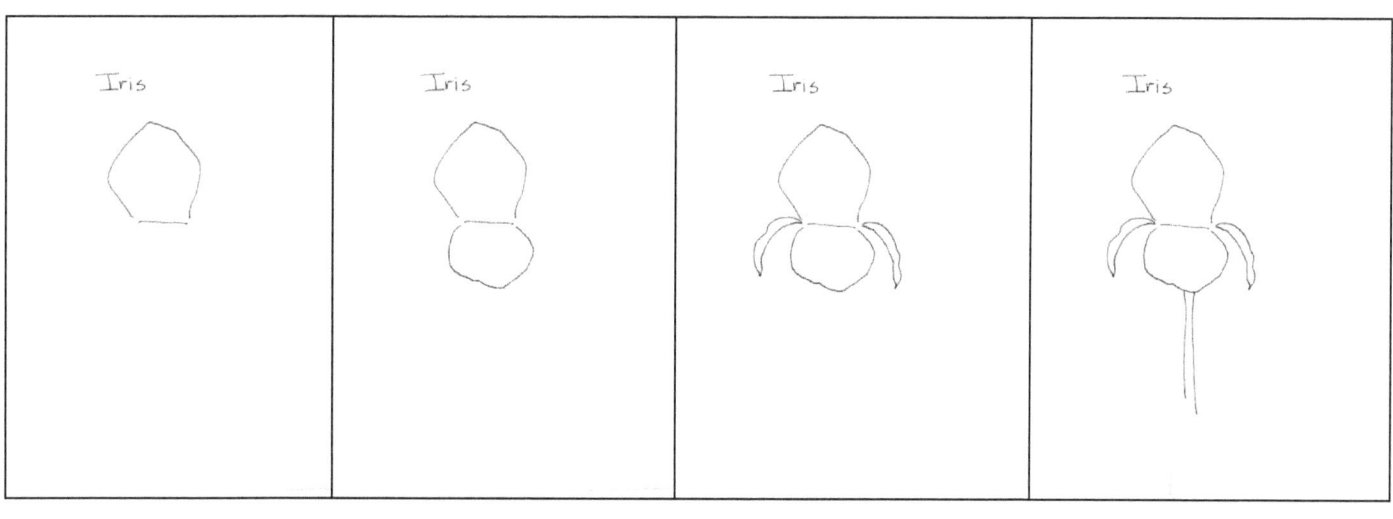

Step 1 Step 2 Step 3 Step 4

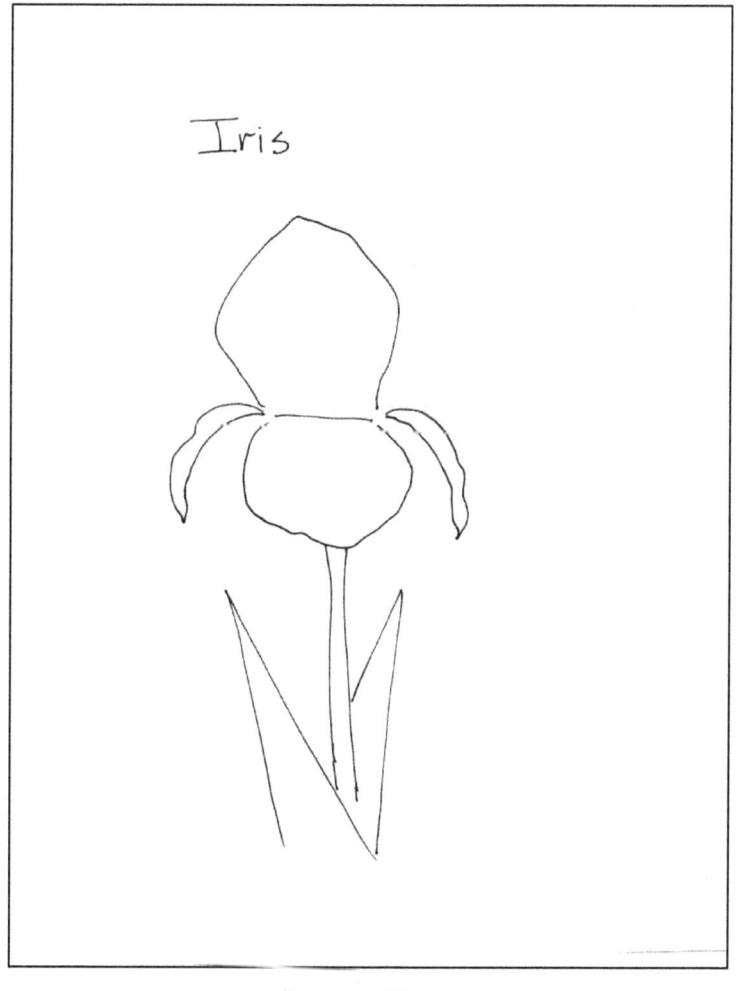

Step 5

DRAW WITH ME: A Flower Garden – Practice Rosebud

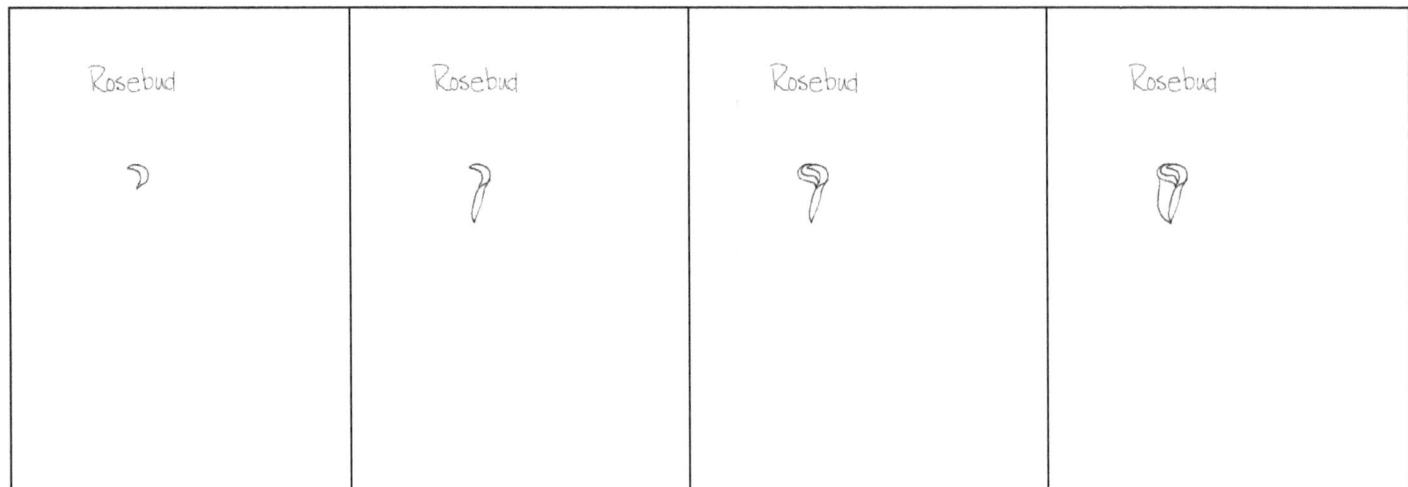

Step 1 Step 2 Step 3 Step 4

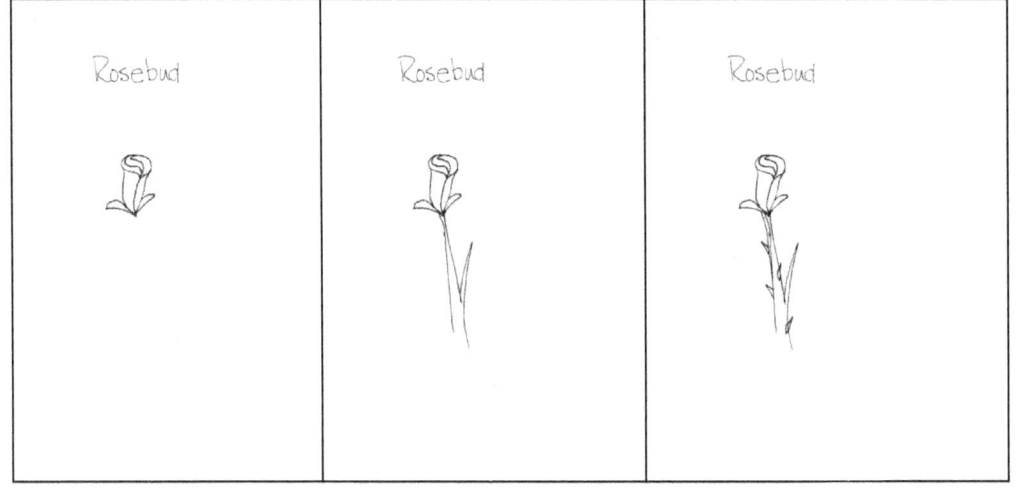

Step 5 Step 6 Step 7

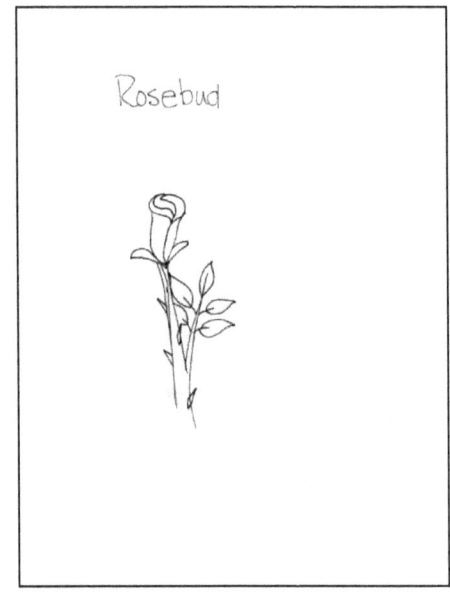

Step 8

DRAW WITH ME: A Flower Garden – Practice Rose

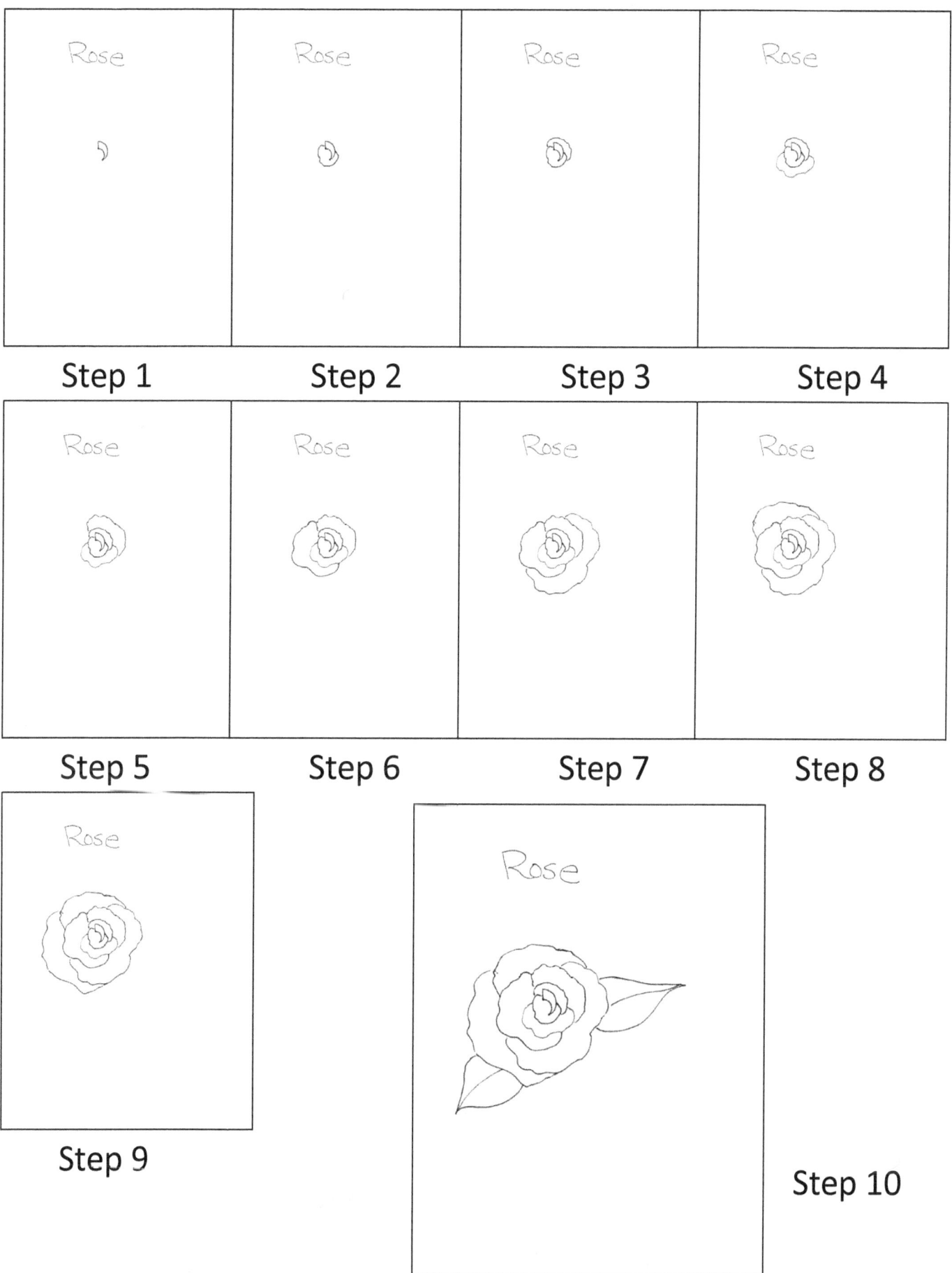

DRAW WITH ME: A Flower Garden – Practice Sunflower

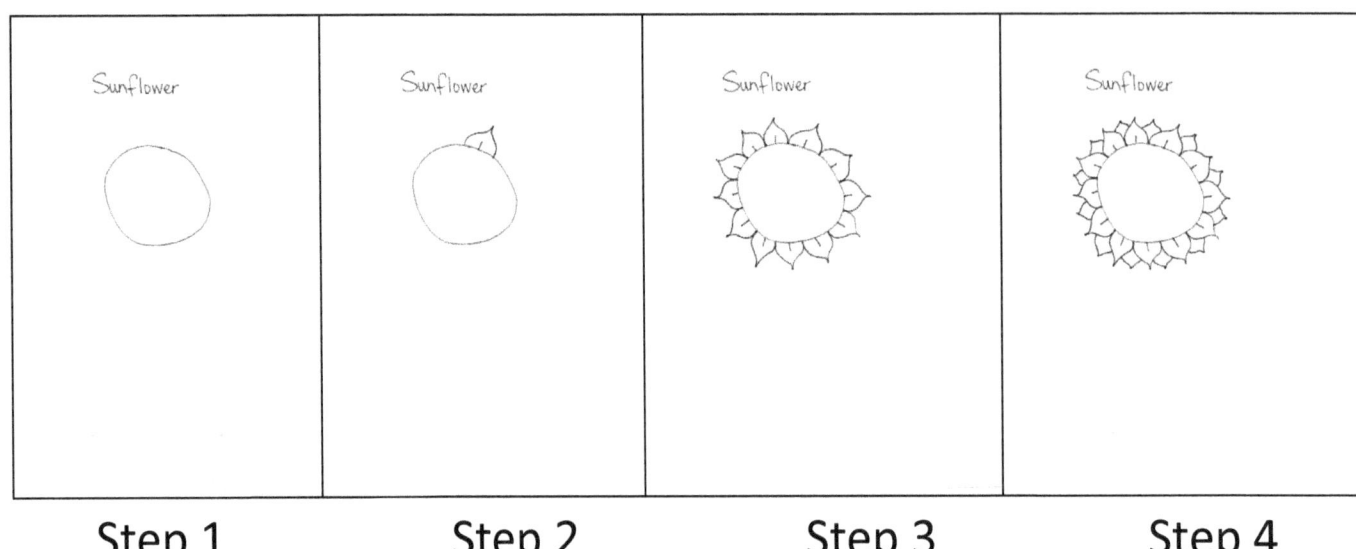

Step 1 Step 2 Step 3 Step 4

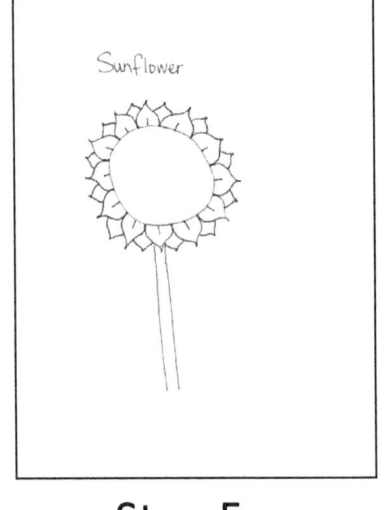

Step 5

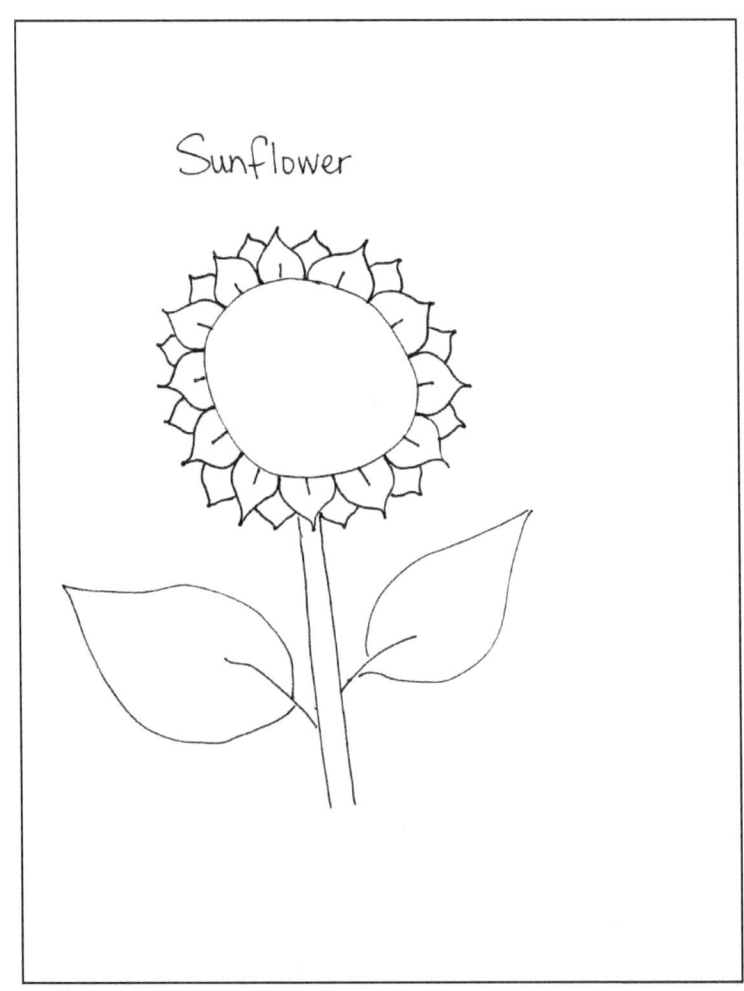

Step 6

DRAW WITH ME: A Flower Garden

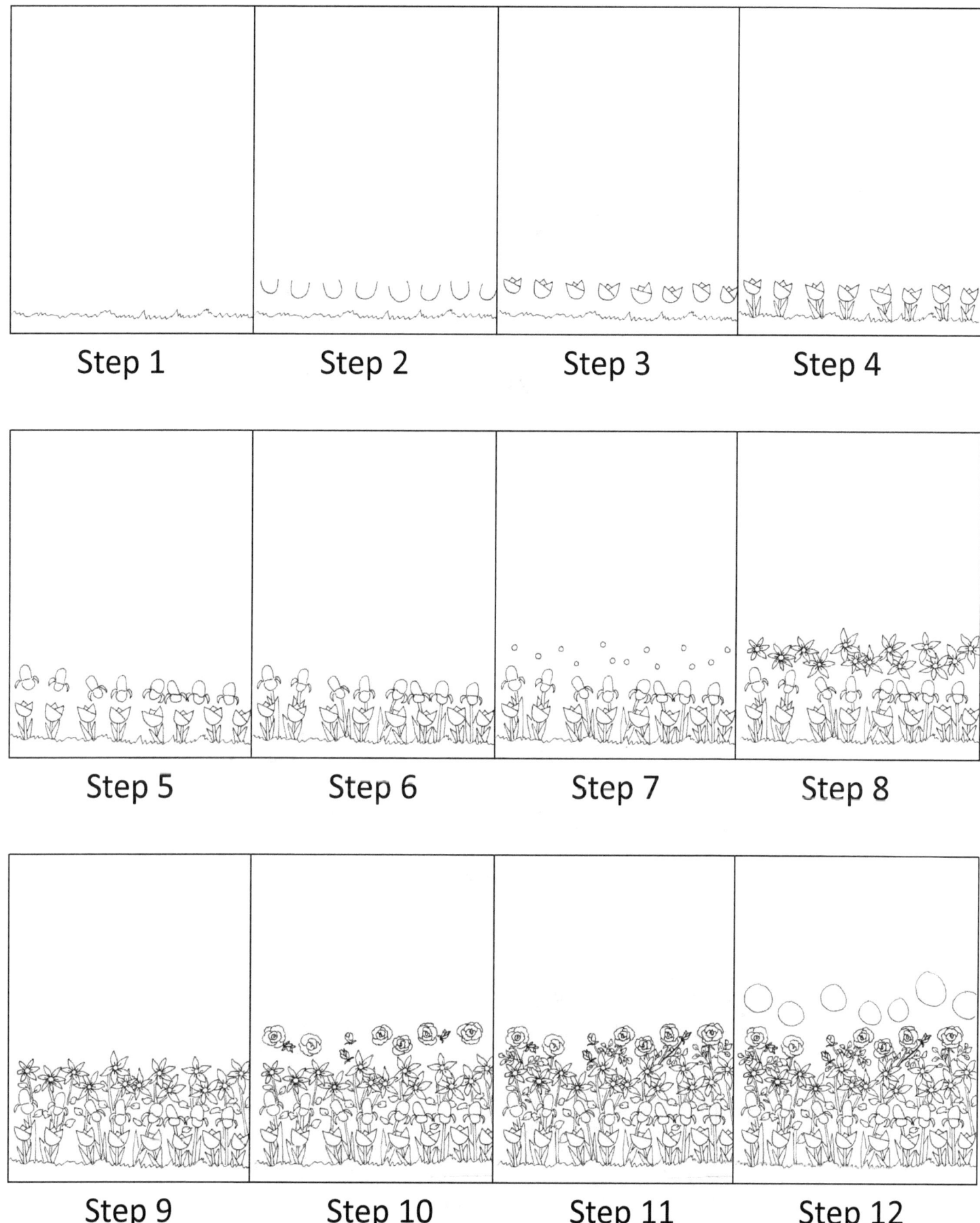

Step 1 Step 2 Step 3 Step 4
Step 5 Step 6 Step 7 Step 8
Step 9 Step 10 Step 11 Step 12

DRAW WITH ME: A Flower Garden continued

Step 13 Step 14 Step 15

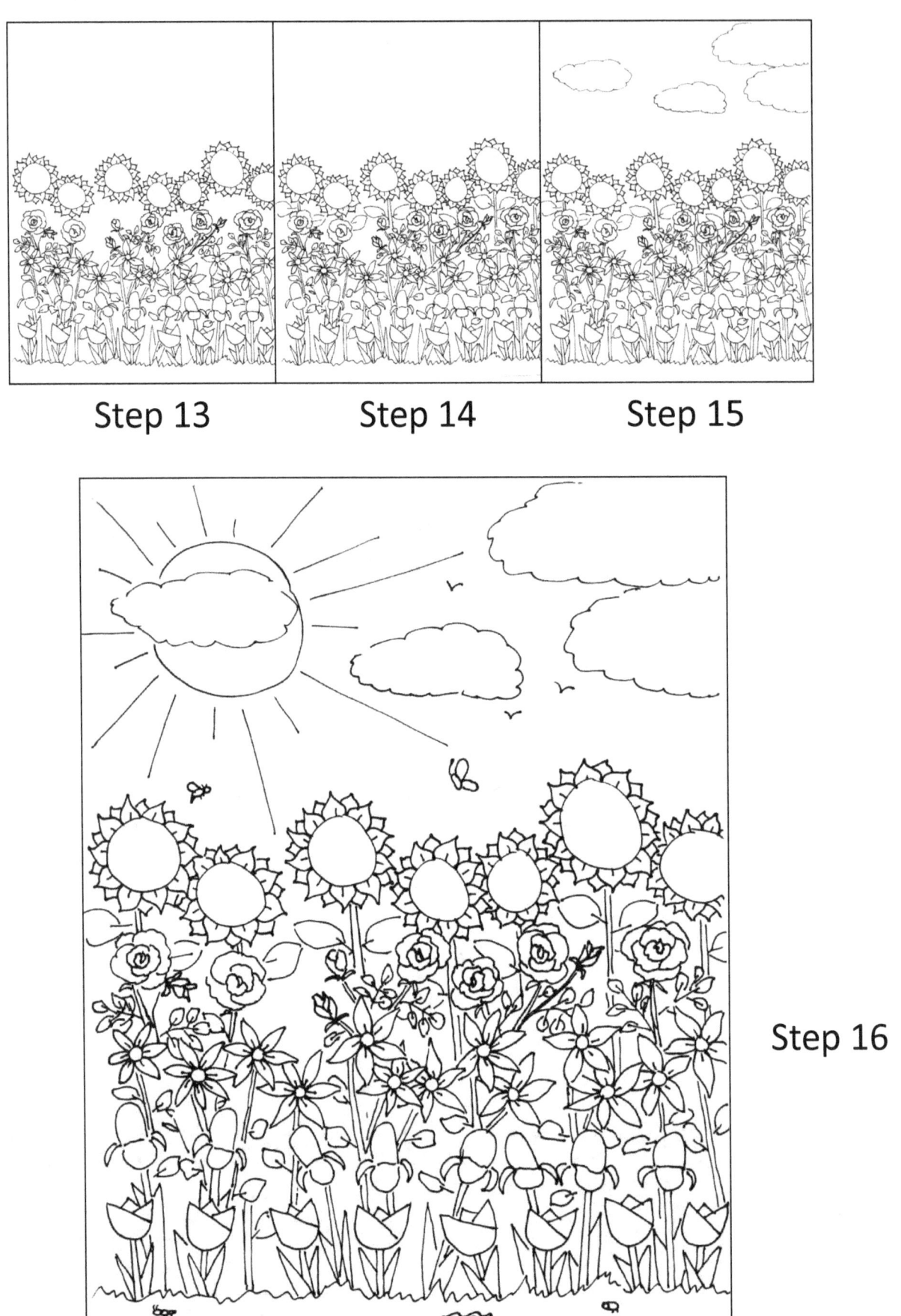

Step 16

NOW IT'S YOUR TURN.....

All these drawings are simply my breakdown of objects and ideas into lines and shapes. The ideas developed over time into the step-by-step instructions I have written here.

Develop your own step-by-step. It takes a little time but it's great fun to share with your little artists.

And they love it when you take the time to draw with them.

Enjoy your art and your artists!

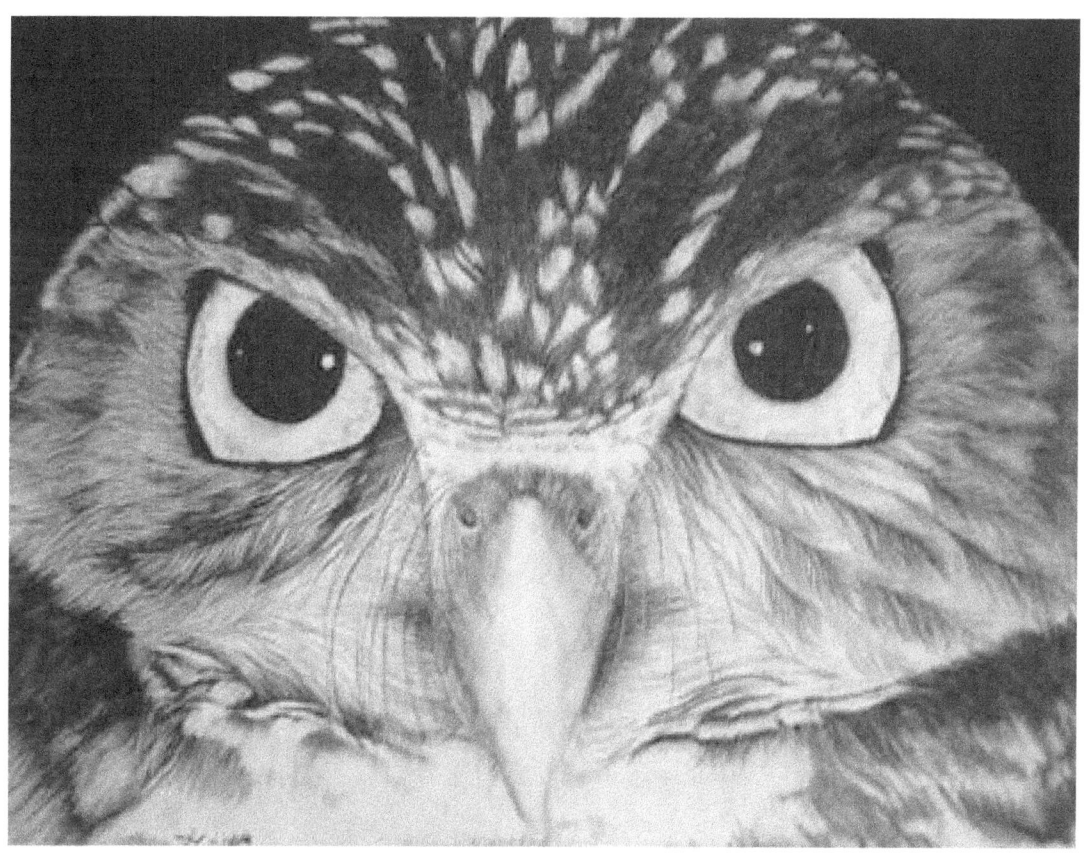

www.ingramcontent.com/pod-product-compliance
Lightning Source LLC
Chambersburg PA
CBHW081908170526
45167CB00007B/3194